HOLBEIN

HOLBEIN

Helen Langdon
with notes by James Malpas

Phaidon Press Limited
140 Kensington Church Street, London W8 4BN

First published 1976
Second edition, revised and enlarged 1993
© Phaidon Press Limited 1993

A CIP catalogue record for this book is available from the British Library

ISBN 0 7148 2867 X

Printed in Hong Kong

Cover illustrations:
Front *Unknown Young Man at his Office Desk*, 1541. Vienna, Kunsthistorisches Museum (Plate 48)
Back *Christina of Denmark*, 1538. (Detail) London, National Gallery (Plate 43)

Holbein

'Add but the voice and you have his whole self, that you may doubt whether the painter or the father has made him.' These confident words are inscribed on Hans Holbein's portrait of *Derich Born* (Plate 26); they, and the elegant young man who leans on the parapet, demand our admiration and compel our belief. It was this quality of life-like immediacy in portraiture that most impressed Holbein's contemporaries. Erasmus wrote to Thomas More, on the receipt of a drawing of More's family, '... it is so completely successful that I should scarcely be able to see you better if I were with you.' Today, our first reaction on looking at a Holbein portrait is perhaps still one of wonder at the sheer skill with which Holbein used all the technical resources of Renaissance naturalism to create an image of completely convincing accuracy. His patient observation of surface detail, of the texture of skin, hair and fabrics is combined with an ability to suggest weight and volume and a sense of the dignity of the human personality. Holbein's sitters are recorded exactly as they were at one particular moment, but there is never any stress on the transitory; they do not greet the spectator with gestures or turned heads; they do not impose their personalities upon us by any play of expression; rather they are characterized by an unusual stillness, precision and clarity. Holbein's eye was unerring, and his approach one of unparalleled objectivity. He rarely allowed any emotion to intrude.

Hans Holbein was born in Augsburg in 1497/8, and his working life may be divided into four periods. He worked in Basle and Lucerne from 1515 to 1526. From 1526 to 1528 he was in London, but returned to Basle for the next four years. From 1532 he was again in London and died of the plague there in 1543.

Little impression of Holbein's own personality emerges from his works. The facts of his life are well documented, but there are no surviving letters or journals which tell us about the man himself; although he knew many famous men of his time he is rarely mentioned in their letters except as a 'wonderful artist'. Best remembered as a portrait painter, he was in fact an immensely productive artist in a variety of mediums.

At the beginning of the sixteenth century German art hovered on the brink of the Renaissance. Throughout the fifteenth century north European artists had been concerned with a faithful imitation of nature, the greatest exponent of which was Jan van Eyck who had developed a brilliant technique of oil painting. His works are based on a tireless and meticulous study of the effects of light as it falls on patiently observed details of fabrics, metals, stone, flowers and grass (Fig. 1). This feeling for the surface and texture of nature remained characteristic of the art of northern Europe for many years, and in this respect Holbein was truly the heir of van Eyck.

However, by the end of the fifteenth century, the splendour of the achievements of Italian artists of the Renaissance had begun to

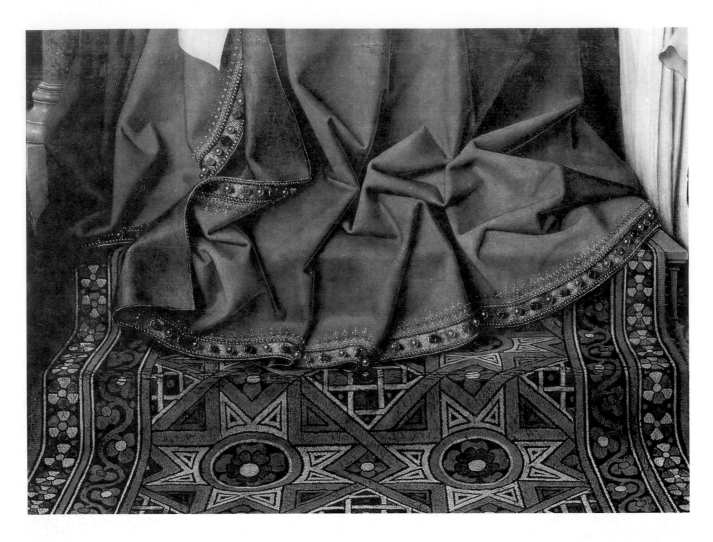

Fig. 1
Jan Van Eyck
The Madonna with
the Canon van der
Paele (detail)
1420. Oil on wood
panel, 122 x 157 cm.
Bruges, Musée
des Beaux-Arts

Fig. 2
Dürer
Oswald Krel
1499. Oil on panel,
49.6 x 39 cm
Munich, Alte Pinakothek

impress their northern contemporaries. Their own art must have begun to seem somewhat old-fashioned as they became increasingly aware of the Italian discovery of mathematical perspective, the Italian conception of the ideal beauty of the human figure (recreated from classical antiquity and based on the scientific study of anatomy) and the dignity and grandeur of classical forms of building.

Albrecht Dürer, who was twenty-six years older than Holbein, was the first German artist to attempt to understand the new principles of Italian art. He visited Italy twice and thereafter his work was a struggle to introduce into German art something of the grandeur of the Italian High Renaissance (Fig.2). Dürer experimented tirelessly with Italian theories about proportion, perspective and anatomy; he tried to widen the narrow religious subject-matter of German art, introducing recondite allegories from classical mythology. Yet Dürer's works always remain recognizably Germanic; he was a melancholic, a man of intense religious convictions, and his art is full of the visionary and the fantastic. In sharp contrast to Holbein we know a lot about Dürer, who was fascinated by his own personality; he discussed himself in letters, journals and notebooks, and reveals himself through his art, as the cooler and enigmatic Holbein was never to do.

Dürer's only northern contemporary of comparable stature was Matthias Grünewald, who in every way represents a total contrast. Grünewald continued to work in the tradition of late medieval art, the aim of which was to communicate religious truths with intensity and passion. His most famous work was an altarpiece now called the *Isenheim Altarpiece*. The central panel shows the Crucifixion, and rarely has this event been depicted with such stark cruelty. Every detail

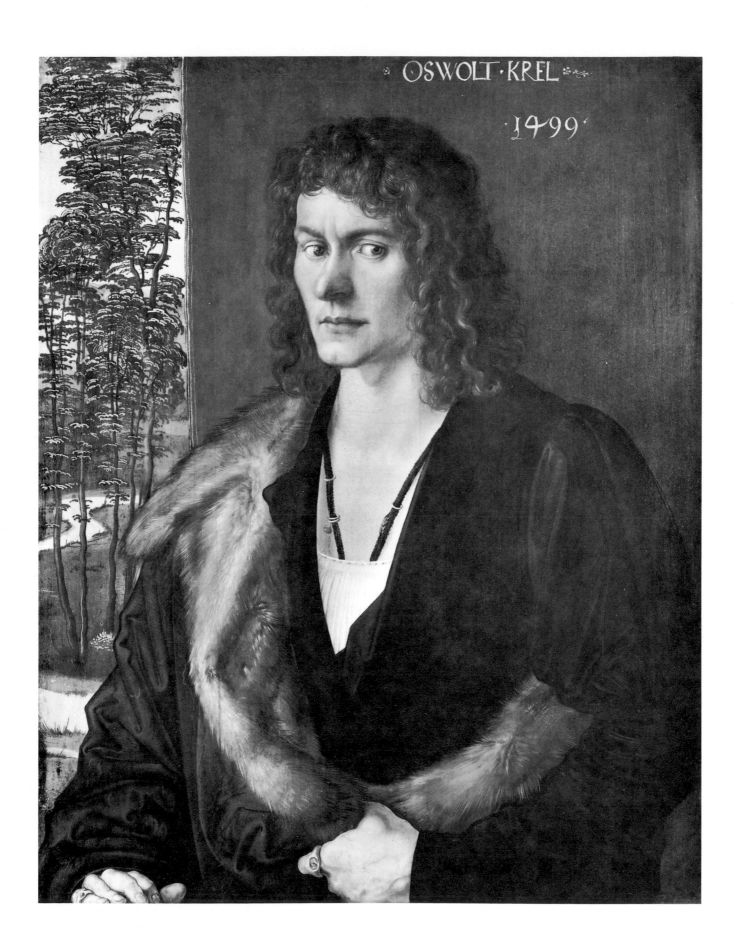

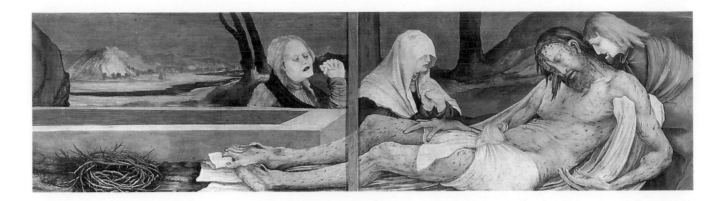

Fig. 3
Matthias Grünewald
The Dead Christ
in the Tomb
(Detail from the
Isenheim Altarpiece)
Oil on panel, 1515.
Colmar, Unterlinden
Museum

emphasizes the agony of Christ's suffering; the body, with the shoulders roughly pulled out of joint, hangs from a rough wooden cross; the decaying green flesh is covered with hideous scars; the hands are convulsed in agony. The painting is the culmination of a tradition of German Gothic paintings which show scenes from the Passion of Christ with the utmost brutality (Fig. 3).

Landscape was another interest of German artists of this period. Lucas Cranach and Albrecht Altdorfer had discovered the beauty of the Alpine districts around the Danube and developed a kind of romantic landscape painting and etching, often enlivened by dramatic effects of light (Fig. 4). An interest in dramatic nocturnal scenes is also apparent in the works of Dürer's follower, Hans Baldung Grien. Holbein was to become one of the most urban of artists, but, in his early religious paintings, he sometimes used romantic landscape backgrounds, and exciting contrasts of night and day. In other ways Holbein had little in common with his near contemporaries in Germany, all of whom were strongly individualistic. Hans Baldung Grien, for example, moved away from the influence of Dürer to explore more shadowy areas of human experience – the erotic, the sensual, the demonic, and the libertine (Fig. 5).

In a narrower context, Holbein's early training in Augsburg would have encouraged an interest in the Italian Renaissance. Augsburg was an important artistic centre, and artists of the preceding generation had begun to assimilate something of the Italian achievement. Hans Burgkmair had travelled to northern Italy, and had opened the eyes of Augsburg artists to the beauty of Renaissance architectural detail; he also experimented with Italian portrait types. Moreover, Holbein's father, Hans Holbein the Elder, was the leading artist of his generation in southern Germany; he was a late Gothic realist, whose capacity for precise and objective observation, particularly apparent in his numerous portrait drawings, anticipated something of his son's. His late altarpieces show the beginnings of a Renaissance interest in symmetry and a purely decorative use of Italian Renaissance architecture. Yet Holbein the Elder was also in touch with Grünewald, and in 1515 moved to Isenheim, when his son moved to Basle.

In Basle Holbein probably entered the workshop of Hans Herbst, with whom his brother Ambrosius was working in 1516. In 1519 Ambrosius died; Holbein became a master of the Basle Guild in that year and probably took over his brother's workshop. About the same time he married Elsbeth Schmidt.

There was a continuing demand for church decorations in the old style in Basle, yet the city was also the centre of classical scholarship and of the European book trade. Johann Froben, friend of Erasmus and publisher of his books, established his press there, and Holbein began to produce book illustrations for him in 1516. In these early

Fig. 4
Albrecht Altdorfer
Landscape
Etching.

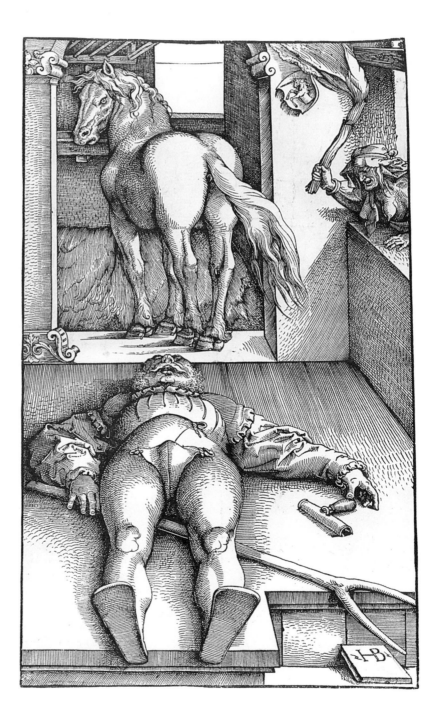

Fig. 5
Hans Baldung Grien
The Bewitched
Groom
Woodcut, 34.5 x 19.4 cm.
Metropolitan Museum
of Art, New York

Fig. 6
Marginal illustration
for Erasmus'
In Praise of Folly
Pen and ink

Fig. 7
Mantegna
The Family of Count
Ludovico Gonzaga
and his Court
c.1472. Fresco. Mantua,
Ducal Palace

years Holbein, not surprisingly, veers between the old and the new. His religious paintings have an expressionist figure style and a violent subjectivity that suggest that he had studied Grünewald; yet he also studied with enthusiasm engravings of classical forms and used them sensitively in his work, often combining details of both classical and Gothic architecture in the same painting. The knowledge that Dürer had struggled so painfully to acquire was more accessible to the younger Holbein. To no other German artist did the potentials of scientific perspective reveal so much.

Holbein was a precocious artist, with an astonishingly mature grasp of form, and in his early works there is an element of exuberant display and delight in a complex treatment of space. He experimented ceaselessly with new problems, applying linear perspective even to book illustration and portraits. In his religious paintings, sweeping movements into depth create effects that are almost melodramatic; his decorative paintings use feigned architecture in a way that approaches *trompe l'oeil*, and are full of wit, gaiety and humour. In these early paintings we can most immediately feel the excitement of the boundless possibilities revealed to a northern artist of this period by the Italian discoveries of the *quattrocento*.

Despite his youth, Holbein was immediately accepted into humanist circles in Basle. He made his artistic debut with some informal marginal drawings that he did in a first edition of Erasmus's *Praise of Folly* of 1515, which later belonged to Erasmus himself. These are remarkable for their wit, humanity and instinctive sympathy with the spirit of Erasmus's irony (Fig. 6).

In the following year, although a young and unknown artist, Holbein attracted the patronage of the rich merchant classes, and painted the burgomaster *Jakob Meyer* and his wife *Dorothea Kannengiesser* (Plates 2, 3). Meyer was later to head the Catholic party in opposition to the reformers, and to commission from Holbein his greatest religious work (Plate 14). The composition of the Meyer portraits is based on a chiaroscuro woodcut of Hans Baumgartner by Hans Burgkmair (Fig. 8); husband and wife are shown against one continuous architectural background which is sumptuous in its elaborate detail and contrasts of red and gold. In this, the first portrait in which Holbein experimented with perspective to create depth, the architecture thrusts forcefully into space. Holbein was always to be far more inventive in his creation of new portrait types than Dürer had been. The bright reds against the blue of the sky, and the elaborate display of gold embroidery and jewellery, emphasize the effects of brilliance created by the architecture. Framed by this fashionably classical setting, the features of the couple remain stubbornly unidealized and sharply observed. They are close in feeling and in pose – particularly in the pose of the woman, with her hands concealed and her arms held away from the body – to the likenesses made by Holbein the Elder. It is a remarkably confident painting for so young an artist.

The showy qualities of the Meyer diptych have been eliminated from the portrait of *Bonifacius Amerbach* of 1519, which is a simpler and more striking work (Plate 4). Amerbach, a close friend of Erasmus, was Professor of Roman Law at Basle University, and owned many works by Holbein which later formed the basis of the famous collection now at Basle. Amerbach dominates his surroundings. The poem, composed by himself, which praises the lifelikeness of the portrait, leads the eye gently into space; the dress is elegantly unobtrusive. The portrait is not prosaically realistic but has a new dignity which expresses something of the humanist confidence in the power of man's intellect.

From 1517 to 1519 Holbein worked in Lucerne, where he collabo-

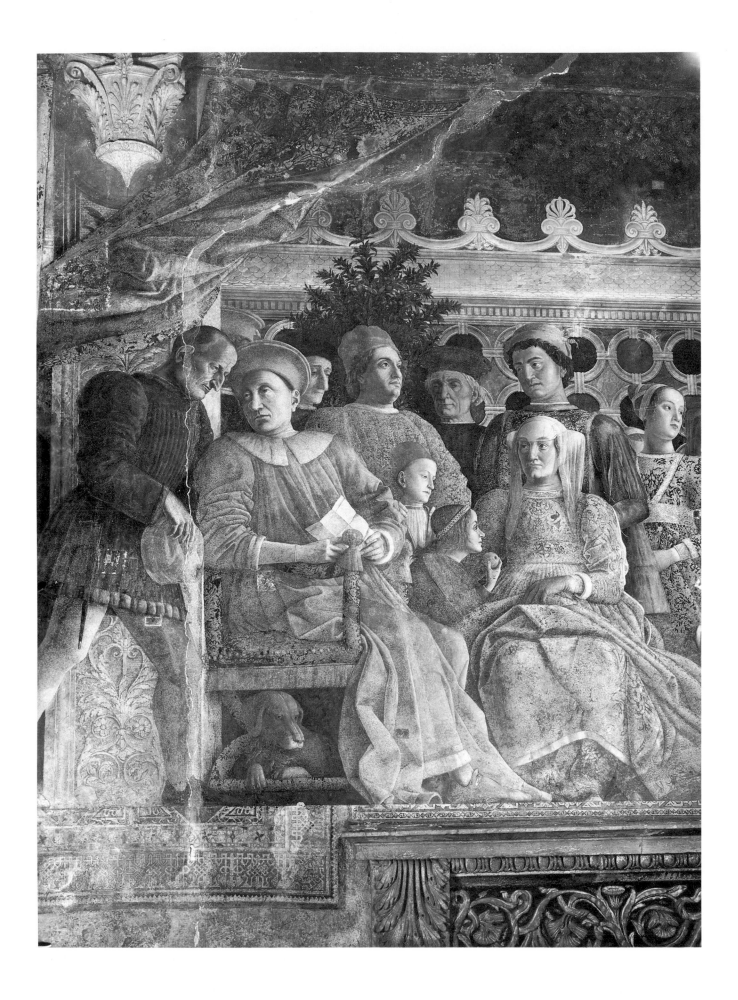

Fig. 8
Hans Burgkmair
Portrait of Hans
Baumgartner
c.1512. Woodcut.
The British Museum

rated with his father on the decorations for the magistrate's residence, the Hertenstein House, now destroyed. This was the first of a series of decorations in which Holbein exploited the possibilities of illusionistic architecture, and which included a pageant scene heavily dependent on engravings after Mantegna's *Triumphs*. It is almost certain that sometime during these two years Holbein went to northern Italy; paintings of the 1520s, such as the *Lais Corinthiaca* (Plate 12) and the group portrait of Sir Thomas More's family, suggest a direct knowledge of works by Leonardo and Mantegna (Fig. 7).

Holbein's early religious works show the influence of Dürer, Grünewald and Hans Baldung Grien. The *Adam and Eve* of 1517 (Plate 1) is based on a woodcut by Dürer of 1510, which shows Adam and Eve embracing as Eve takes the apple; in Holbein's painting the tender melancholy of Adam's expression seems to suggest his awareness of the ensuing tragedy.

The figures in *Christ as the Man of Sorrows* and the *Mater Dolorosa* are also Düreresque; the complex architectural background plunges into space and, though the forms are classical, the sweeping movements and clash of geometrical shapes increase the emotional fervour; it is an idiosyncratic combination of southern forms with Germanic feeling. A further group of works from this period show scenes in which classical architecture is illuminated with dramatic, often nocturnal, lighting effects.

In the early 1520s Holbein achieved a truer balance between north and south. His *Dead Christ* of 1521 (Plate 8) is unimaginable without the example of Grünewald, yet nowhere is Holbein's capacity for detached and merciless observation more apparent. His painting makes no overt appeal to the emotions, there is no exaggeration of bodily agony in expression or gesture; yet it does move us to pity and fear because of its painfully accurate and unflinching description of the structure of the body, the putrid and decaying flesh turning green around the wounds, the swollen lips, sunken eyes and rigid hands.

The two shutters of an altarpiece (Plate 5) conclude this early phase of Holbein's development. Although the format and subject recall earlier German paintings, Holbein here tells the story of the Passion of Christ with a straightforward and human directness that is new in German art; the figures have lost the spikiness and bonelessness of the late Gothic style and become sturdy and compact, standing firmly on the ground. Both Christ and his persecutors are humanized, and Christ himself is no longer a pallid and pure victim. Holbein stresses the passionate intensity of his suffering in the garden, and the reluctant knowledge with which he submits to Judas's extravagant embrace; perhaps most astonishing is the unemotional representation of his body on the cross. Nor are his persecutors snarling animals in extravagant medieval armour; they are calm and grave, wear Roman dress, and their elegant poses recall Mantegna. *The Entombment* is based on Raphael's composition in the Borghese (see Fig. 17), but Holbein has broken up the classic grace and flowing movement of Raphael's painting in the interests of a starker realism.

In the *Meyer Madonna* of 1526 (Plate 13) all remnants of a Gothic format have gone; of all Holbein's paintings this most nearly approaches the grandeur and calm symmetry of Italian Renaissance compositions. The painting shows the Madonna of Mercy sheltering the praying family of Jakob Meyer beneath her cloak. In 1526 the two sons died, and between 1528 and 1530 Holbein added the profile portrait of Meyer's first wife, thus commemorating Jakob Meyer's whole family. The portraits retain a northern realism, but their expressions and taut poses suggest a spirituality that is far removed from the

worldliness of the earlier Meyer portraits (Plates 2, 3). The painting has an unusual combination of the majestic and the intimate; the composition is open and the group of figures brought close to the world of the spectator.

The soft painting of the flesh in the *Meyer Madonna* reveals the influence of Leonardo, whose work continued to interest Holbein throughout the 1520s. Nowhere is this more apparent than in the *Lais Corinthiaca* of 1526 (Plate 12), for which Holbein used the same model. Both the subject-matter – the model is shown as a Greek hetaira (dancing-girl) – and the overtly Italianate quality, which suggests Raphael as well as Leonardo, are unusual in Holbein's work.

Up till this period Holbein's career had been immensely varied and extremely productive; as well as portraits and religious paintings, he had produced designs for painted glass, woodcuts, façade decorations, and, in 1521-2, he had begun a series of wall paintings in the great Council Chamber of Basle town hall, which, within a framework of feigned architecture, showed scenes from classical history intended to advise the councillors.

Before 1526 he had produced a series of woodcuts illustrating the *Dance of Death*. Holbein's ironic tone throughout the series contrasts sharply with contemporary, more expressionist treatments of the subject. Death appears as a mocker, attacking every class of humanity and – as he snatches the Emperor's crown during the distribution of Justice, and fixes around the countess's neck a chain of bones while she makes a lavish toilet – reveals the futility of worldly power and concerns (Fig. 9). Some of the same social types are also shown on a design for a dagger sheath, where Holbein shows the dead and the living dancing together. The series is remarkable for its variety and for the precision of Holbein's feeling for different social types.

By the mid-1520s, however, the violent disturbances associated with the Reformation put an end to this productivity. Religious paintings were viewed with disfavour and Holbein decided to look for work in England.

The choice of England was perhaps encouraged by Erasmus, and his portraits of Erasmus form the prelude to the humanist portraits of Holbein's first English period. Erasmus settled in Basle in 1521 and Holbein supplied his publisher, Froben, with woodcuts for his books. Erasmus was the most famous classical scholar in Europe, sought after by princes and high churchmen; his portrait was done by many artists – amongst them Dürer and Quentin Massys – yet today we cannot imagine him without thinking of Holbein, in whom we sense a deep understanding of his irony, detachment, wit and seriousness.

Erasmus was attracted by the idea of exchanging portraits with his friends; he had already presented Sir Thomas More with a double portrait of himself and Petrus Aegidius by Quentin Massys. In 1524 Holbein took a portrait of him to France; in the same year two portraits by Holbein were sent to England, one of which was presented to Archbishop Warham (see Fig. 25).

In the fifteenth-century portraits of scholars, usually Saint Augustine or Saint Jerome, surrounded by books and writing materials, were common. In the sixteenth-century this portrait type was adapted to the humanist scholar, and Massys's and Holbein's portraits of scholars are variations on this theme. Massys tends to be more informal, and to attempt to create something of the atmosphere of the study. Holbein's portraits of Erasmus are more definitive celebrations of the supreme scholar. In the painting in the Louvre (Plate 11) Erasmus is shown in profile, writing at his desk; no details distract from this portrayal of a powerful intelligence, and the charmingly dec-

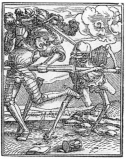

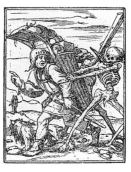

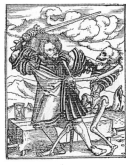

Fig. 9
Hans Lützelburger
after Hans Holbein
the Younger
Woodcuts from
'Dance of
Death' series
1524. Paris,
Bibliothèque Nationale

orative background adds a touch of intimacy and acts as a foil to the powerful modelling of the head.

In 1526 Holbein left for England. He carried with him a letter of recommendation from Erasmus to the Antwerp scholar Petrus Aegidius, asking the latter to introduce him to Quentin Massys. 'The arts are freezing in this part of the world', wrote Erasmus, 'and he is on his way to England to pick up some angels there.' Holbein probably also carried letters to Erasmus's friends in England.

Holbein's belief that England was the home of the arts at this time was not without justification. Henry VIII's reign had opened full of promise for the revival of classical learning; John Colet, who had travelled in Italy, was lecturing at Oxford from 1496 to 1504; Warham, Erasmus's friend and patron, was Archbishop of Canterbury; Wolsey had established himself as a great patron of learning and was encouraging Italian craftsmen and sculptors to work in England; poets flocked to Henry's court, and Wyatt and Surrey were introducing the Petrarchan sonnet. Sir Thomas More, after the publication of his *Utopia* in 1516, achieved a fame in Europe that paralleled that of Erasmus.

More exchanged letters with the greatest scholars of his day, amongst them Erasmus, Vives and Cranevelt, and was visited by them. Erasmus himself visited England several times in the early years of the century and was tempted to settle there; his letters give some idea of the atmosphere of optimism and hope with which the humanists awaited the rule of reason, learning, moderation and mercy. In 1499 he wrote to Robert Fisher, 'And I have met with so much learning, not hackneyed and trivial, but deep, exact, ancient Latin and Greek, that I am not hankering so much after Italy except just for the sake of seeing it. When I hear my Colet, I seem to be listening to Plato himself. In Grocyn who does not wonder at that perfect compass of all knowledge? What is more acute, more profound, more keen than the judgement of Linacre? What could nature ever create milder, sweeter or happier than the genius of Thomas More?' In 1518 Erasmus wrote to Henry VIII, praising him for his establishment of a Golden Age of universal peace, justice and scholarship.

Holbein arrived in England in 1526; More, who had been established in a position of power at court since 1521, wrote discouragingly to Erasmus, 'Your painter, dearest Erasmus, is a wonderful man; but I

Fig. 10
Family of Sir
Thomas More
1526. Pen and ink,
38.8 x 52.4 cm. Basle,
Öffentliche
Kunstsammlung

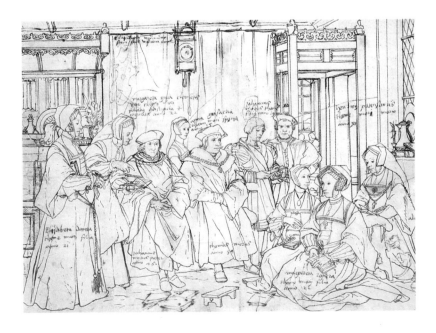

fear he won't find England as fruitful as he had hoped. Yet I will do my best to see that he does not find it absolutely barren.' More was, of course, aware of the lack of any tradition of portrait painting in England; he was probably also aware of the troubled times to come; the Reformation, which had caused Holbein's departure from Basle, was soon to reach England. However, More kept his word, and for the best part of the years 1526-8, Holbein stayed in Chelsea, painting More, his family and friends (Fig. 10).

Holbein's portraits from this first short stay in England have a particular interest in that they capture much of the dignity and nobility of More and his circle in this period of hope. The portraits are characterized by a warmth of human feeling and by an undramatic presentation that convinces us of its complete truthfulness. They are perhaps the most approachable of Holbein's portraits; the flawlessness of his technique, the patient description of details which create the superbly realistic likenesses, does not call attention to its own perfection as it tended to do in the later portraits.

The portrait of *Sir Thomas More* (Plate 18) dates from 1527. Compared with the earlier portraits of Erasmus, this painting has a new monumentality and grandeur; the body confidently fills a space clearly defined by parapet and curtains. It is one of Holbein's most direct and precise portraits, and shows his meticulous observation of surface texture, of the wrinkles around the eyes and nose and the stubble on the chin. Yet it also has a dignity that we associate with the great portraits of the Italian Renaissance, with Raphael's *Castiglione* (Paris, Musée du Louvre; Fig. 12) or Titian's *Gentleman in Blue* ('Ariosto') (London, National Gallery; Fig. 27). More is here the statesman, wearing rich dress and the chain which was an emblem of service to the king; yet we also feel in the stillness of the pose, and in the latent vitality of his features and hands, a sense of the restrained intellectual power of the scholar.

In the same year Holbein also painted William Warham, Archbishop of Canterbury (Paris, Musée du Louvre; Fig. 25). As we have seen, Warham owned one of Holbein's portraits of Erasmus (now at Longford Castle) and he had himself painted in the same pose; the portrait was intended as a return gift.

To the same period belongs the superb portrait of an *Unknown Lady with a Squirrel and a Starling* (Plate 19). The monumental design and delicate treatment of detail link it with the portrait of *Sir Thomas More* (Plate 18). The suggestion of quiet dignity is common to both. The brilliant description of the squirrel, complete with a small chain held in the lady's hands, shows the breadth of Holbein's skill and sympathies.

The portrait of *Nicolas Kratzer* (Plate 25), astronomer to Henry VIII, tutor to the children of Thomas More, friend of Dürer and life-long friend of Holbein himself, dates from 1528. Kratzer is shown, posed in a quiet moment of thought, surrounded by the instruments of his profession; the still-life attracts almost as much attention as the sitter. To the English, unaccustomed to the wonders of Renaissance naturalism, the accuracy of Holbein's treatment of the still-life must have been startling. Careful attention is paid to the texture, size, lighting, and exact location in space of every object; the *trompe l'oeil* painting of the objects hanging on the wall must have seemed little short of miraculous.

The most worldly of the portraits of the period are the pair of *Sir Henry Guildford*, Controller of the Royal Household (Plate 20), and *Lady Guildford* (Plate 21), both dated 1527. An impression of bulk and weight dominates both paintings; Sir Henry's dress in particular is rich

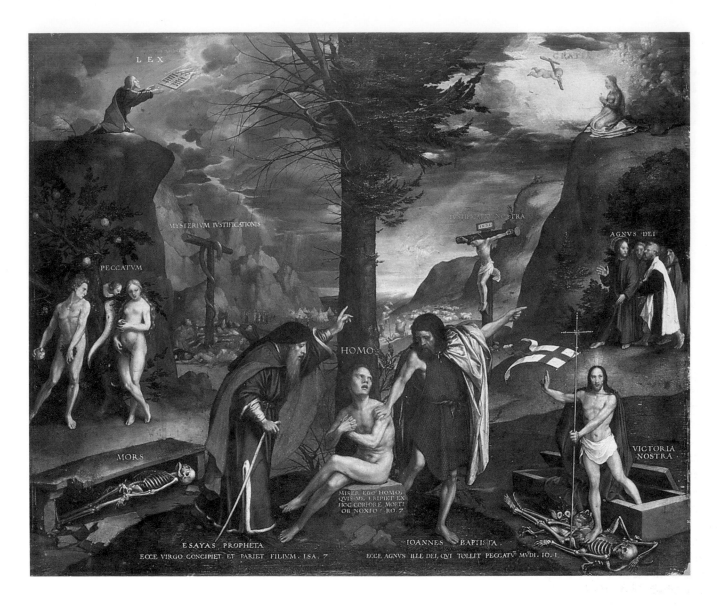

Fig. 11
The Old and the
New Law
c.1535. Oil on oak
panel, 49 x 60 cm.
Edinburgh, National
Gallery of Scotland

and lavish, and much gold paint has been used in the costume and in the collar of the garter. A drawn curtain defines the space behind Sir Henry, a Renaissance column with tie-beam the space behind Lady Guildford.

This handful of portraits is all that remains of Holbein's first English period. His most remarkable work was a large group portrait of Sir Thomas More's family, which has since been destroyed. It measured eight feet high and thirteen feet across, and was painted in watercolour on linen or canvas. We know what it looked like from a pen-sketch by Holbein of the composition (Basle; Fig. 10), which was sent to Erasmus in 1526, and from an old copy by Richard Locky painted in 1530. The painting showed More and his father seated in the centre, surrounded by their family; they were shown reading, or discussing, or pointing out interesting details to each other in classical texts. The painting must have recreated much of the atmosphere of More's remarkably scholarly household, in which women as well as men received a classical education, and which Erasmus, in a famous letter, described as Plato's Academy on a Christian footing. The painting was the first large-scale portrait-group done in northern Europe and suggests that Holbein knew Mantegna's frescoes of the Gonzaga family in Mantua.

Holbein had been given only two years leave of absence by the authorities in Basle and in 1528 returned there and bought a house. In

1529, however, the full fury of the Reformation reached Basle. The City Guild ordered all paintings to be taken out of the churches and destroyed. Holbein seems eventually to have complied with the Reformers, yet that he had doubts may be inferred from a document of 1530 in which Holbein asked to be given a better explanation of the Last Supper before partaking of the Lutheran Communion.

Holbein was not completely inactive over the next four years. He did further work on the Council Chamber decorations in Basle town hall; he produced designs for book illustrations and stained glass; he painted Erasmus again. It seems likely, too, that during this period he revisited north Italy, for in the early 1530s there seems to be a renewed influence in Holbein's work from the portraits of Raphael (Fig. 12) and Leonardo. By 1532, however, he seems to have realized that there was little possibility of finding a fruitful source of patronage, and he returned to England.

One of Holbein's most moving paintings dates from this second Basle period, that of his wife and two children (Plate 10). Of all Holbein's portraits this is the most emotionally expressive, particularly in the suffering face of the mother and in the painfully anxious but expectant faces of the children. The beautifully integrated composition was suggested by the traditional Italian format for paintings of Mary with Christ and John the Baptist; the classic structure and this allusion to a religious theme give the portrait a weight and significance that reaches beyond the personal.

The England of 1532 was dramatically different from that of 1528. Holbein fled from the Reformation in Basle to find England on the edge of a revolution. Henry VIII's desire to marry Anne Boleyn and divorce Catharine of Aragon had led him to break with Rome and to claim Imperial status for the kings of England: in 1534 the Act of Supremacy, which gave the Crown authority over the affairs of the Church of England, was passed. Almost all Holbein's earlier patrons became involved in the ensuing disturbances. Warham and Guildford died in 1532; More resigned from the chancellorship and was to be executed in 1535 for refusing to take the oath required by the Act of Supremacy; Surrey was executed and Wyatt imprisoned. Henry VIII had effectively put an end to the development of classical scholarship in England.

Thus it was imperative that Holbein should find new sources of patronage, and between 1532 and 1536 most of Holbein's patrons were members of a trading community in London, merchants of the German Steelyard. For their procession to celebrate Anne Boleyn's coronation he designed a triumphal arch depicting Apollo and the Muses. He also painted two large wall decorations on canvas, *The Triumph of Riches* and *The Triumph of Poverty*, for their hall, which became famous throughout Europe (Plate 31, Fig. 28). For the most part, however, his commissions were for small half-length portraits, in which the sitter is shown in his office, often with his accessories of work scattered about, and holding a letter bearing his name and address.

The earliest of these, dated 1532, is of the Hanseatic merchant *Georg Gisze of Danzig* (Plate 22). The portrait is unusually elaborate, and the brilliance of the *trompe l'oeil* still-life suggests that Holbein was deliberately exhibiting his skill to attract further commissions. In 1533 he painted *Derich Born* (Plate 26), a portrait of supremely confident elegance, in which the pose suggests the renewed influence of Raphael and Leonardo. As in Leonardo's *Mona Lisa* (Paris, Musée du Louvre), the head faces outwards, while the body is turned to the side, and the near arm brought close to the picture plane. In the same year

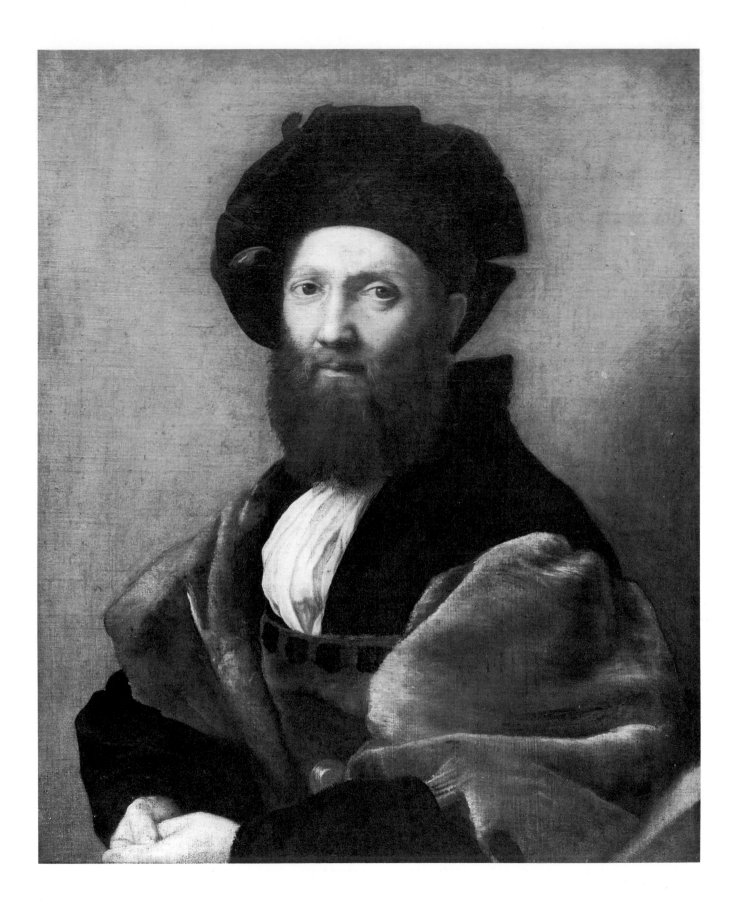

Holbein painted *Robert Cheseman* (Plate 24), and here Holbein used the plain background with the gold lettering that became frequent in the later years; the impression of depth is created by the figure alone. In a sense both these paintings are transitional works, which combine something of the amplitude of the earlier English portraits with the sharper contours and more perfectly rounded forms and abstract settings of the later period.

A very different work from this period, *The Ambassadors* of 1533 (Plate 16), also showed foreigners in England. This ambitious painting is a life-size double portrait of Jean de Dinteville, French Ambassador to London, and Georges de Selve, the Bishop of Lavaur. Between them are two shelves covered with an array of objects, which indicate their knowledge of sciences, religion and the arts (Fig. 13). At first sight the grand scale and superb realism of the painting make it appear an overwhelming statement about Man's potential and attainment; yet the heraldic symmetry of the composition is roughly broken into by the blurred shape that obscures part of the mosaic floor. This is a human skull, painted in a distorted perspective, which assumes its true shape when seen from the bottom right corner. This reminder of death is taken up in other details of the painting. There is a crucifix in the top left corner; the badge on de Dinteville's hat shows a human skull; and the string on the lute is broken. The painting thus celebrates Man's power whilst at the same time reminding us of the ultimate futility of human endeavour.

The portrait of Jean de Dinteville's successor, as ambassador to the English court, *Charles de Solier, Sire de Morette* (Plate 23), shows a comparable richness and amplitude. The *Unknown Gentleman with Music Books and Lute* (Plate 27) is also shown against a curtain; its folds add visual interest to the background. However, the later portraits of the merchants of the German Steelyard tend to be simpler; the mood one of restraint and quiet dignity. This tendency towards simplicity, and the elimination of all accessories, is characteristic of his late portraits. After 1535 the sitters are usually shown in the full light, focused against a background of blue or green, and very often in simple frontal poses. Holbein was, through a reduction of means, seeking a more abstract beauty of form. Nothing distracts from the clarity of his contours, nor from the perfection of the technique with which he describes, brush-stroke by brush-stroke, details of hair, skin and fabrics. There is a quality of stillness and remoteness in the late portraits.

The change in Holbein's style may be clearly seen in the portrait of *Sir Richard Southwell* of 1536 (Plate 29). The line here detaches itself far more sharply from the background than hitherto, and relentlessly circumscribes Southwell's rather unpleasant and self-satisfied expression. Southwell had helped to betray Sir Thomas More, and it is at this stage in Holbein's career that we fully understand how coldly detached he could be.

In yet later portraits the sitter tends to become larger in relationship to the picture plane, as in the portrait of *Anton the Good, Duke of Lorraine* (Plate 47). We become more conscious of the part that the frame plays in relating the sitter to the picture plane; the panels are smaller, and there is an impression of increased concentration and precision. The *Unknown Young Man at his Office Desk* (Plate 48) is a superb example.

The portraits of English royalty form rather a separate category in his work. Somewhat surprisingly he did not enter the royal service until 1537, but his potential seems to have been recognized by Thomas Cromwell, whom he painted in 1534. Cromwell, throughout

Fig. 12
Raphael
Portrait of Baldassare
Castiglione
1513. Oil on wood
transferred to canvas,
82 x 66 cm. Paris,
Musée du Louvre

Fig. 13
Detail from
'The Ambassadors'
(Plate 16)

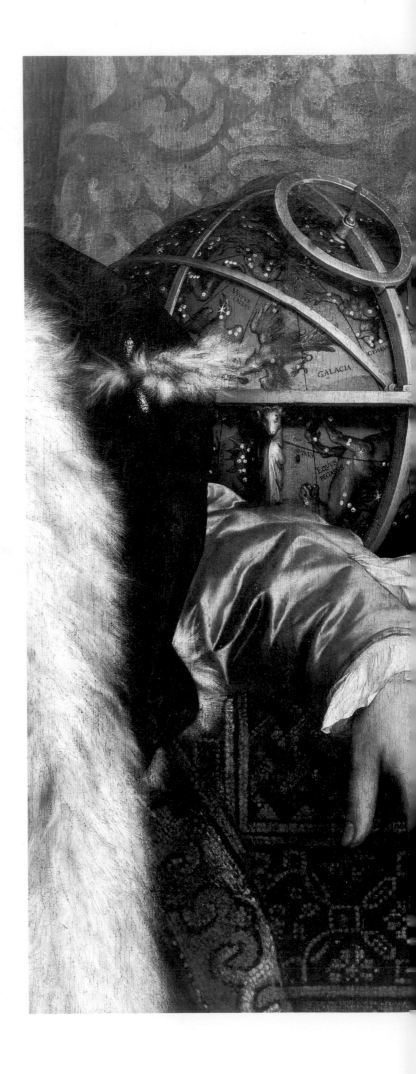

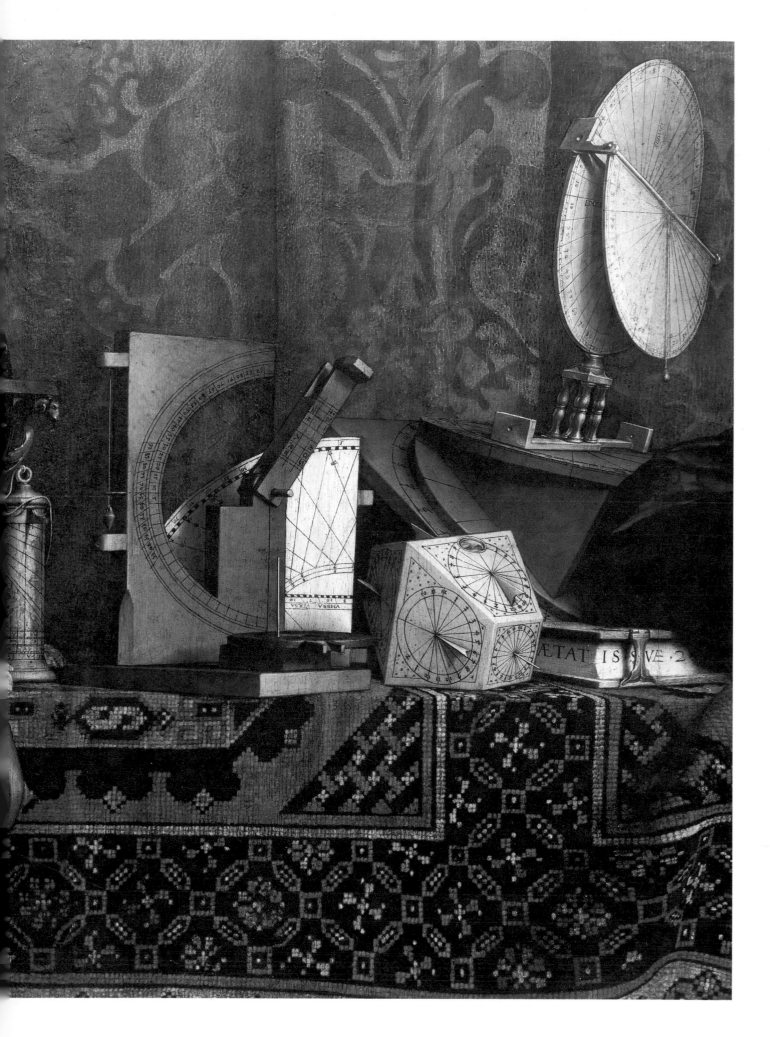

the 1530s, with the aid of a team of pamphleteers, was carrying out a propaganda campaign to create an image of royalty so powerful that it should compel the loyalty formerly reserved for the more ancient power of Rome. His master-stroke, perhaps, was to realize how Holbein could communicate these new concepts in paint, and it is Holbein's vision of Henry VIII, massive, ruthless and dominating, that still persists today.

Holbein's royal portraits, then, concentrate on the expression of an idea, and for them he evolved a style which depends on the rich patterning of dress and jewellery. The bodies no longer occupy space but are schematized, and the surfaces encrusted with glowing decorative detail which seem to take on a ceremonial significance; the whole has the effect of an icon, of a hieratic image of royalty.

Although Holbein created a standard type for portraits of Henry VIII, only one portrait of him is now accepted by all scholars as being from Holbein's own hand. This painting (Plate 36) was almost certainly the pair to the portrait of *Jane Seymour*, Henry's third wife (The Hague, Mauritshuis). Amidst the linear flatness of her dress, Jane Seymour's face does retain some character, albeit of rather prim timidity. Henry's massive head is depicted without warmth, and expresses the merciless power he possessed.

Fig. 14
Remigius Leemput
after Hans Holbein
the Younger
The Tudor Dynasty
(the 'Privy Chamber
Mural')
Oil on canvas,
88.9 x 98.7 cm.
Hampton Court Palace,
Royal Collection

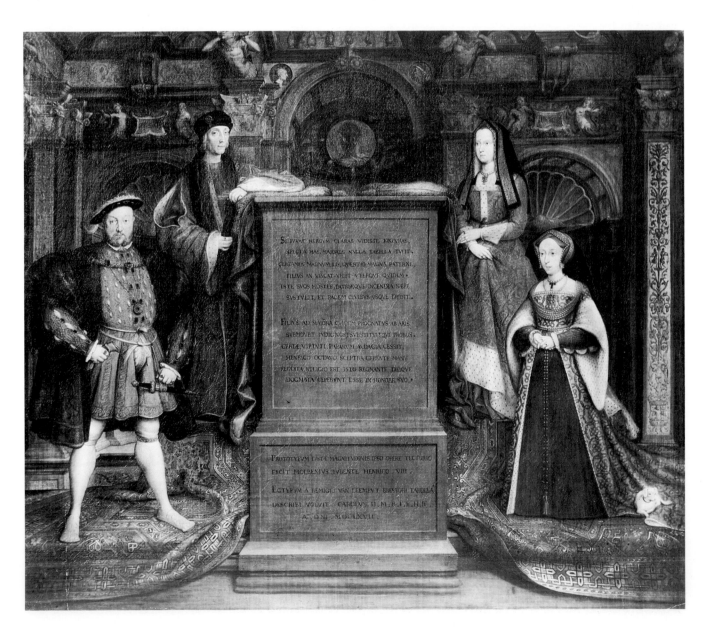

In 1537 Holbein executed a large wall painting for the Privy Chamber in the palace of Whitehall, now destroyed (Fig. 14). This showed Henry – with Jane Seymour, Henry VII and Elizabeth of York – as head of the Tudor dynasty; Henry himself was shown life-size in a dominating frontal stance with legs apart. It is not surprising to read in an early account that visitors were 'abashed, annihilated' in his presence. Henry's supreme power was also the subject of a miniature which shows him as *Solomon Receiving the Homage of the Queen of Sheba* (Plate 32).

In 1537 Jane Seymour died after the birth of the future Edward VI. Immediately Henry, aided by Cromwell, began to look for a new wife, ideally one that should combine political advantage with Henry's desire for physical beauty. Henry's idea was that all the possible brides in France should be brought to the French coast and inspected by him; not surprisingly this idea was rejected by Francis I. Henry therefore decided to send Holbein to paint all candidates for his hand and throughout 1538 and 1539 Holbein was occupied with this commission.

His first journey was to Brussels, in 1538, to paint Christina of Denmark, the widowed Duchess of Milan; the marriage negotiations, however, came to nothing. Later in 1538 Holbein set off for France to paint Renée of Guise and Anne of Lorraine. After this journey he returned to Basle for a month, where he was fêted by his fellow-citizens. The City Guild unsuccessfully tried to retain his services with offers of a pension, two years leave of absence, and liberal conditions of work. In 1539 Holbein was sent to Düren to paint two daughters of the Duke of Cleves, Anne and Amelia. Henry VIII finally married Anne of Cleves in 1540; but, ironically, after all his precautions, he developed a violent physical aversion to her and divorced her a few months later.

The most successful result of these journeys is the portrait of *Christina of Denmark* (Plate 41). His achievement is all the more astonishing when we realize that he was granted a sitting of only three hours, during which he probably made a likeness in chalk or watercolours, working it up into a full-length portrait after his return to England. Amongst Holbein's royal portraits the painting is remarkable for its fresh perception of the individual, whilst retaining all the formality of the state portrait. The sitter gazes directly at the spectator; her features are soft and sensitive, seemingly capable of movement and expression. Christina, touchingly youthful in her widow's robes, is not locked into a flat pattern of dress and jewellery. Her solid form stands away from the brightness of the background and casts a shadow against it. There is even a suggestion of movement in the way that her dress clusters around her feet. The beauty of the effects that Holbein has here created with a daringly simple composition and a narrow yet beautifully modulated range of colours and texture, is still more remarkable if we remember his earlier taste for a display of complexity.

The portrait of *Anne of Cleves* (Plate 40) has none of the vivacity of the *Christina of Denmark*. The painting is in watercolour on parchment and shows Anne of Cleves in her wedding clothes. Holbein probably sketched her whilst in Düren and later elaborated it into a marriage portrait. The painting is severely formal, and a splendid decorative array of reds and golds is set against the plain green background; face and hands are absorbed into the overall effect and there is little impression of character or individuality.

The portrait of *De Vos van Steenwijk* (Plate 37), like the *Christina of Denmark* (Plate 41), shows well the relaxed mastery of his later work.

All Holbein's skill is now lavished on such details as the hairs in the beard, the eyelashes and the pattern on the lapels of the surcoat. The desire – perhaps even need – to display technical virtuosity, so evident in *The Ambassadors* (Plate 16), has passed, creating an image that is as compact as it is uncluttered.

Holbein not only created the official image of Henry VIII, which has kept its hold on the popular imagination until the present day, but also captured the whole atmosphere of the Tudor court as it passed through one of the most dramatic periods of English history. There survives, as well as several paintings of the men and women who surrounded Henry VIII, the famous volume of drawings now preserved in the Royal Library at Windsor Castle, which almost certainly remained in Holbein's studio until his death. This contains eighty-five portrait drawings of men who played a leading part in the making of Tudor history; only a few of the drawings may be connected with surviving paintings. Where the paintings are known, however, they frequently follow the drawings very closely indeed; for example, the painting of *Sir Richard Southwell* (Plate 29) follows the drawing (Plate 28), even down to such details as the rather casual arrangement of the buttons in the collar. Drawing had always been the basis of Holbein's style and these portrait drawings are not quick sketches or impressions, but carefully worked-out statements about the sitter's personality.

These drawings, naturally, have a particular interest for an English public in that they supply us with a detailed description of the most famous and glamorous personalities from the reign of Henry VIII. They include physicians, maids-in-waiting, military commanders, poets and men of letters, amongst them Wyatt, Surrey and Sir Thomas Elyot (Plate 35), author of the *Governor*, who retired from the dangerous world of politics when he heard of the execution of his friend Sir Thomas More (Plate 18). It also includes men who were involved in diplomacy and affairs of state – More himself, protégés of the Lord Chancellor, Thomas Cromwell, amongst them Southwell and Sir John Godsalve. The drawings reflect a turbulent and troubled time, and it is interesting, on looking through the volume, to see how many of these men who held positions of power were arrested for treason, and how many were executed. Holbein's unerring feeling for types of humanity moves with ease from the noble calm of More and his circle to the tough ambition and capacity for cold intrigue that is present in the faces of some of Cromwell's circle. Occasionally, with a meticulous technique, he shows the dandified and languorous elegance of the court hanger-on, as in the portrait of *Simon George of Quocote* (Plate 39), for which there is a drawing at Windsor (Fig. 30).

The only other English king who attracted an artist of such genius to his court was Charles I, and a comparison between the achievement of Van Dyck and Holbein is perhaps illuminating. Van Dyck's success depended on his sympathy with the poetic sensibilities of those around him; he seems to have submerged himself in the ethos of the Caroline court and put into paint all the glamour and grace of that court's vision of itself. Van Dyck's portraits of elegant cavaliers and their ladies, standing on terraces before columns and velvet curtains, tend to blur together in our minds; it is the beauty of the idea that we remember. With Holbein the reverse is true; we remember a series of immensely vital and immediately convincing personalities recorded without poetry and without flattery by an artist whose rigorous discipline and grasp of essentials allowed no sentiment to intrude. His drawings stubbornly emphasize the core of the human personality and concentrate on the individuality of the sitters.

Stylistically, the drawings, as we might expect, follow much the same development as the paintings. Those of the first English period are the most broadly conceived and boldly handled. Sketched on white paper in black and coloured chalks, they have a grandeur and nobility that is lacking from the later drawings. From the 1530s Holbein used paper primed with carnation, modelling the features in black chalk and adding details of the hair and ornaments in Indian ink with either the brush or pen. The beginning of this more refined technique is apparent in the drawings of the early 1530s, as in those of *Sir Thomas Elyot* and *Lady Elyot* (Plates 35, 34), where the penwork has a new subtlety and delicacy. Occasionally in the later 1530s Holbein made very elaborate drawings with minutely precise detail; more commonly, particularly in drawings associated with royalty where presumably the sittings were brief, the tendency is to eliminate all detail and to concentrate solely on a schematic outline. For some of his later portraits Holbein seems to have used a mechanical tracing device.

Holbein's work for the English court did not stop at portraits; he also produced designs for court dress, necklaces, jewellery (Plate 38), hat-badges and brooches. More than two hundred and fifty designs for craftsmen, particularly goldsmiths, are attributed to him, and he was responsible for much of the plate and weapons in use at Henry's court. His decorative style shows a delight in flowing Renaissance forms of exuberant and sophisticated complexity that contrasts sharply with the direct realism of his portraits.

The most lavish and ornate design for goldsmith's work now surviving is *Jane Seymour's Cup* (Plate 33), which was ordered by Henry when he married Jane Seymour in 1536. The initials of Henry and Jane, entwined with true-lovers knots, are set in the band beneath the four circular medallions containing busts *all' antica*. A band round the stem contains the queen's motto: 'Bound to obey and serve', which is repeated on the cover. The design has all the grace and stylish refinement that we associate with European mannerism; few other examples of such calibre were to find their way to England.

It was also in England that Holbein began to paint portrait miniatures. He seems to have learned the technique from an artist called Lucas Hornebout, a Flemish painter in the service of Henry VIII. Holbein's miniatures do not differ essentially from his large-scale paintings; his famous miniature of *Mrs Pemberton* has all the precision of line and clarity of structure of larger portraits (Plate 46). Holbein's miniatures were to be praised by the most famous English miniaturist, Nicholas Hilliard, who later in the century wrote, 'Holbean's maner of limning I have ever imitated and howld it for the best'. Hilliard's miniatures, however, transform the miniature from the reduction of a large-scale painting into a jewel-like and daintily patterned *objet d'art*.

Holbein died in 1543, at a comparatively early age. He did not, as Van Dyck was later to do, redirect the course of English painting. Although the Elizabethan interest in pattern may owe something to Holbein's royal portraits, his style was not easily imitated. His clinical insistence on truthfully recording what he saw could not create a fashion as could Van Dyck's romanticizing approach to his subjects. But the men that Holbein painted still live for us through his eyes. The portraits of Henry VIII and Thomas Cromwell represent totally different aspects of humanity from those embodied in Erasmus and More, yet Holbein created the definitive images of all four men, and this is perhaps the measure of his detachment. The portraits of More and Cromwell, placed side by side, pin-point and hold for ever a turning point in English history.

Outline Biography

1497/8 Born in Augsburg.

1515 After early training in his father's studio, moves to Basle with older brother Ambrosius.

1517 Brothers visit Lucerne, where Hans does interior and exterior house decorations. They may also have made visits to Italy in this period.

1519 Brothers again visit Lucerne. Hans becomes a member of Basle painters' guild and takes over his brother's studio.

c.1520 Ambrosius Holbein dies.

1520 Elected Chamber Master of the painters' guild. Becomes citizen of Basle. Carries out further house decoration projects and produces a design for the Great Council Chamber of Basle Town Hall.
About this date he marries Elsbeth Schmid, a tanner's widow with one son.

1523-4 Travels through France and the Netherlands, searching for employment and patronage, without success. Paints portrait of Erasmus.

1524 Death of the painter's father, Hans Holbein the Elder.

1526 Hans visits Antwerp and then travels on to England, arriving in London by December.

1527 Paints portrait of Sir Thomas More.

1528 Paints the More family; leaves England by the summer. Returns to Basle and buys a house there.

1531 Buys the house adjoining his own. Affirms allegiance to reformed religion, although outbreaks of iconoclasm restrict artistic prospects in the city.

1532 Again travels to England via Antwerp, arriving in London by July. Works on decorations for the Guildhall of the German steelyard there.

1533 Paints the double portrait known as 'The Ambassadors'.

1536 Recorded working for King Henry VIII at salary of £30 a year. He is employed by the German mathematician and instrument maker Nicholas Kratzer to carry Protestant books to Thomas Cromwell.

1538 Travels to Brussels on royal business; paints a portrait of Christina of Denmark as possible bride for Henry VIII; moves on to France.

1539 Travels to Dueren to portray Anne of Cleves.

1543 Dies suddenly in London, of the plague; leaves two illegitimate children.

Select Bibliography

General Works

A. Chamberlain, *Hans Holbein the Younger*,
London, 1913

P. Ganz, *The Paintings of Hans Holbein*, London,
1950

H.W.Grohn, *Hans Holbein der Juengere als Maler*,
Leipzig, 1955

H.W.Grohn and R. Salvini, *L'Opere pittorica
completa di Holbein il Giovane*, Milan, 1971

F. Grossmann, 'Holbein Studies I' and
'Holbein Studies II', *The Burlington
Magazine*, 1951

D. Piper, 'Holbein the Younger in England',
Journal of the Royal Society of Arts, 1953

A.E. Popham, 'Hans Holbein's Italian
Contemporaries in England', *The Burlington
Magazine*, 1944

J. Roberts, *Holbein*, London, 1979

J. Rowlands, *Holbein: the paintings of Hans
Holbein the Younger*, Oxford, 1985

F.Saxl, 'Holbein and the Reformation' in
A Heritage of Images, London, 1970

R. Strong, *Holbein and Henry VIII*, London,
1967

Exhibition Catalogues

Exhibition of Works by Holbein and other Masters,
Royal Academy, London, 1950–1

Holbein and the Court of Henry VIII, The
Queen's Gallery, London, 1978–9

'The King's Good Servant' Sir Thomas More,
National Portrait Gallery, London, 1977–8

List of Illustrations

Colour Plates

Text Figures

Comparative Figures

1 Adam and Eve

1517. Oil on paper mounted on wood, 30 x 35.5 cm. Basle, Öffentliche Kunstsammlung

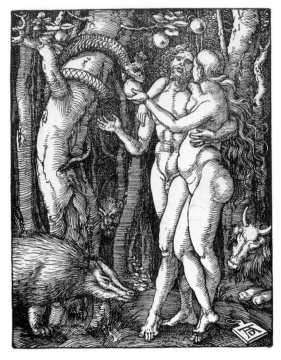

Fig. 15
Albrecht Dürer
The Fall of Man
1511. Woodcut print,
12.7 x 9.7 cm.
London, British Museum

By 1515 Hans Holbein and his elder brother Ambrosius had left Augsburg to establish themselves in Basle and were travelling to nearby towns like Lucerne to carry out commissions, often in journeymen teams. Their father, Hans the Elder, was also involved in such projects.

Though no prodigy (he was nearly twenty when this work was done) Hans shows how he has already assimilated the contemporary 'Swiss' style in the unidealised, thinly-painted figures, whose faces abound with penti-·menti – such corrections can be seen around Adam's eyes. The strongly linear nature of his art is already evident in the fluid, abstracted line of Adam's shoulder. This is memorably combined with the telling realism of the worm-eaten apple Eve holds up to view. Such attention to transitory and corrupt nature (exemplified by Adam and Eve) was a frequent concern of artists in the German schools – Dürer (see Fig.15), Hans Baldung Grien (Fig. 5) and Grunewald (Fig. 3). Each explored this realm: Holbein's own spectacular contribution is the *Dead Christ* (Plate 8). The emotional tone, of regret and world-weariness, is established with considerable subtlety in the faces of the transgressing couple, without the melodrama of much contemporary work, and presages the mature Holbein's psychological insight.

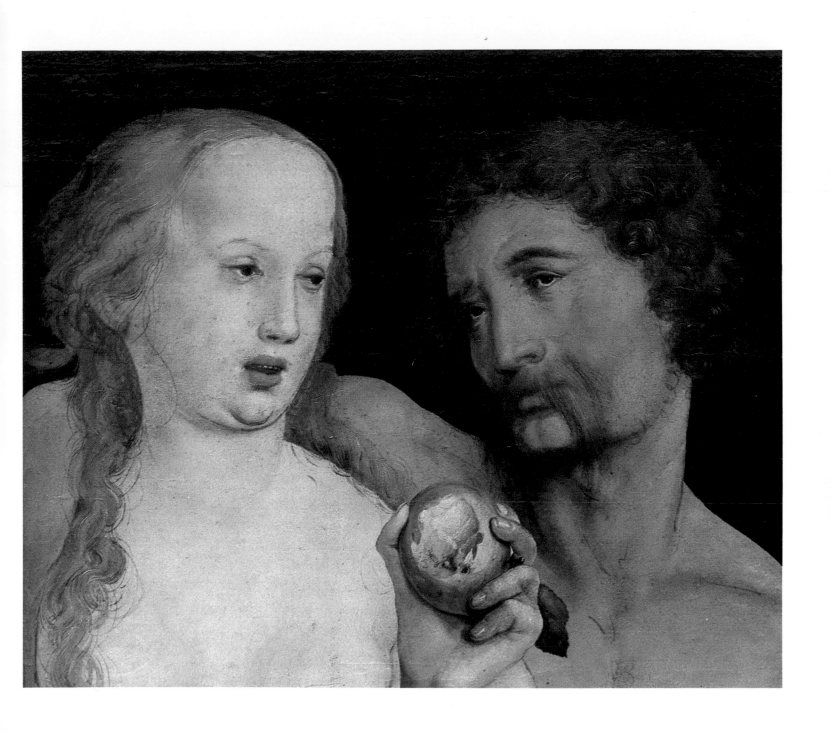

2 Jakob Meyer

1516. Oil on wood, 38.5 x 31 cm. Basle, Öffentliche Kunstsammlung

The transference of artistic knowledge and material from Italy northwards through the Alpine passes during the late fifteenth and early sixteenth century led to the emergence of italianate portrait-construction in Germany. This was being practised with increasing confidence by the time Holbein received his first commissions. Dürer was crucial here, primarily through his Venetian visits in 1496–7 and 1506. Holbein eschewed most of the emotionalism intricately bound up in Dürer's view of the world (see Fig. 2) and once having developed his ability to make a calm appraisal of the sitter's condition, as demonstrated here, maintained it throughout his career. This has led to the mistaken belief that little or nothing changed in his technique over thirty-five years.

As a result of the power and poise of Holbein's preliminary silverpoint portrait, line dominates over colour and texture throughout the painting, except, ironically, in the face. The lines of the bunched fingers compel attention more against the undifferentiated dark jacket, and the illustrative rigour of the architectural background belies the subtlety of light and shadow in the face, perhaps revealing an overly self-conscious borrowing of italianate design at this early stage in the artist's career.

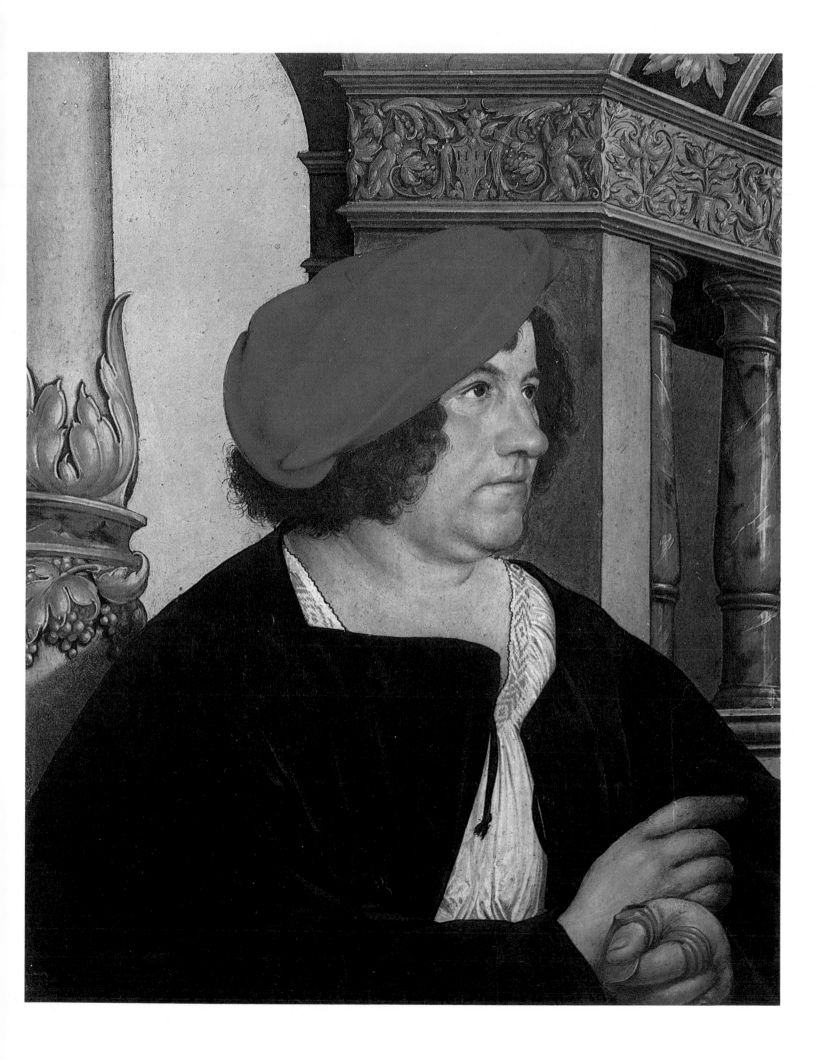

Dorothea Kannengiesser

1516. Oil on wood, 38.5 x 31 cm. Basle, Öffentliche Kunstsammlung

The gilded coffering and pillar enhance the appearance of sober opulence in this striking and forthright depiction of Dorothea Kannengiesser, the second wife of Jakob Meyer. Their double-portrait, signed and dated 1516, was probably commissioned to celebrate Meyer's election as burgomaster. This had crucial repercussions for Holbein's career; evidently pleased with such an impressive diptych from so young an artist, Meyer gained Holbein numerous commissions in the following few years. Meyer was a member of the increasingly important mercantile class in Basle and the first of its members to achieve significant administrative power. (The coin he holds signifies his money-dealing role and also perhaps Basle's new-found permission to mint coins.) His friends and colleagues were therefore in the financial position to aid Holbein through their patronage. Meyer's tenure was brief, however – in 1521 he was impeached for accepting a larger bribe than was permitted from the French, imprisoned when he protested at his treatment and barred from office thereafter. He remained a Catholic after the city's secession to the reformed religion and led the Catholic party in the city: Holbein would perceive such strength of character again, in the analogous determination of Sir Thomas More to remain true to his faith (see Plate 18).

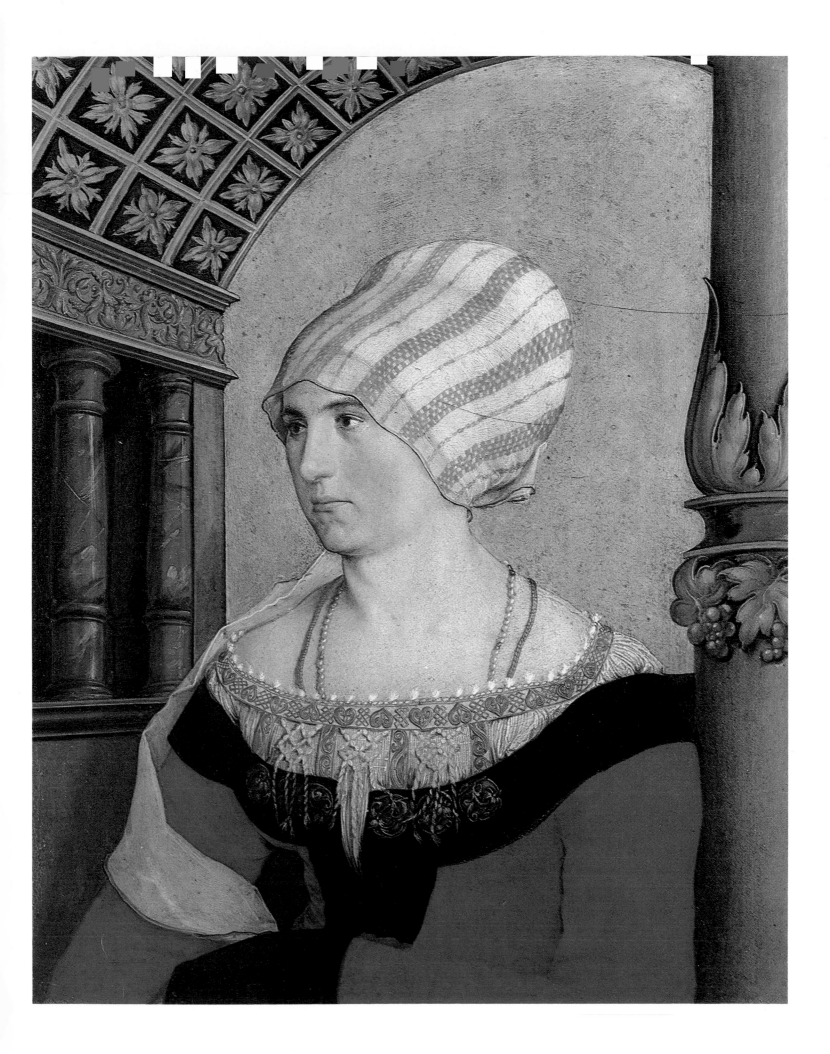

4 Bonifacius Amerbach

1519. Oil on wood, 28.5 x 27.5 cm. Basle, Öffentliche Kunstsammlung

The year 1519 was marked by civic success for Holbein; he was made a Master in the painters' guild *'zum Himmel'*, took up Basle citizenship and married. Until this date much of his daily work had been for the decorative arts, particularly glass-painting and book-illustration, but a new emphasis on portraiture, fomented by the success of the Meyer commission (Plates 2 and 3), first emerges with this piece.

Holbein was lucky to have Amerbach as a friend and patron; the dogged and determined gaze of the withal kindly scholar, eventually Professor of Law at the university, was to be borne out in his assiduous collecting of Holbein's Basle *oeuvre*.

The work is more painterly than the Meyer double-portrait and uses classical references with more confidence, as is appropriate in a portrayal of Amerbach in academic black. The panel bears Amerbach's own words of praise for the artist's truthfulness to nature and it also serves, pictorially, to emphasize the depth of illusory picture-space. As a result sitter and background are well-integrated, and real poetic feeling is glimpsed in the distant snow-covered mountains and chill blue sky.

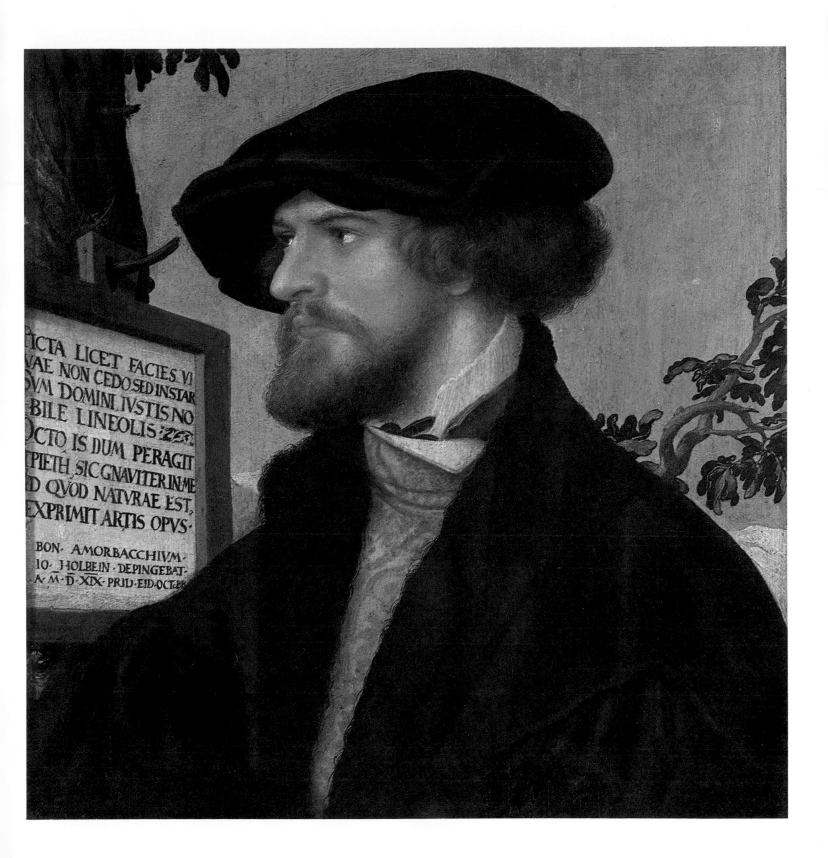

PICTA LICET FACIES VI
VAE NON CEDO SED INSTAR
VM DOMINI IVSTIS NO
BILE LINEOLIS:
OCTO IS DUM PERAGIT
PIETH, SIC GNAVITER IN ME
D QVOD NATVRAE EST,
EXPRIMIT ARTIS OPVS·

BON· AMORBACCHIVM·
10· HOLBEIN· DEPINGEBAT·
A· M· D· XIX· PRID· EID·OCTOB·

The Passion of Christ

c.1524. Oil on wood, four panels 150.3 x 148.1 cm. Basle, Öffentliche Kunstsammlung

Religious paintings form a significant part of the work Holbein produced in Basle. From modest, private commissions in the period 1519–20 (for example, the *Man of Sorrows*), through the *Dead Christ* of 1521 (Plate 8), his interpretation grew increasingly painterly, culminating in the broad sweep of emotion and design seen in the *Passion*. The coherence of the work is underlined by the decorative framework and is the result of Holbein's continued study of Italian masters. Holbein's maturity is evident in the way such derivations – the lighting from Raphael's Vatican frescoes, the armour from Mantegna-esque sources – are combined with a natural, native power of religious expression, dramatic and full of particularized incident, which produces a result quite different from the lofty idealism of the Italian Renaissance . This change can be charted by comparing the *Entombment* here with Raphael's 1507 version (see Fig. 16). The use of limewood panels, the tendency to depict contemporary dress (as worn by some of the mercenaries haranguing Christ) and the supernaturalistic nocturnal lighting, show the northern tendency predominant.

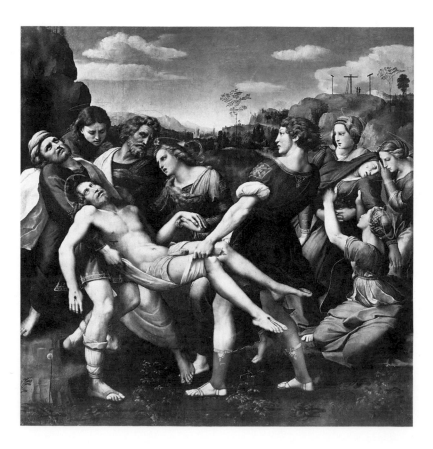

Fig. 16
Raphael
The Entombment
1507. Oil on panel,
184 x 176 cm.
Rome, Galleria Borghese

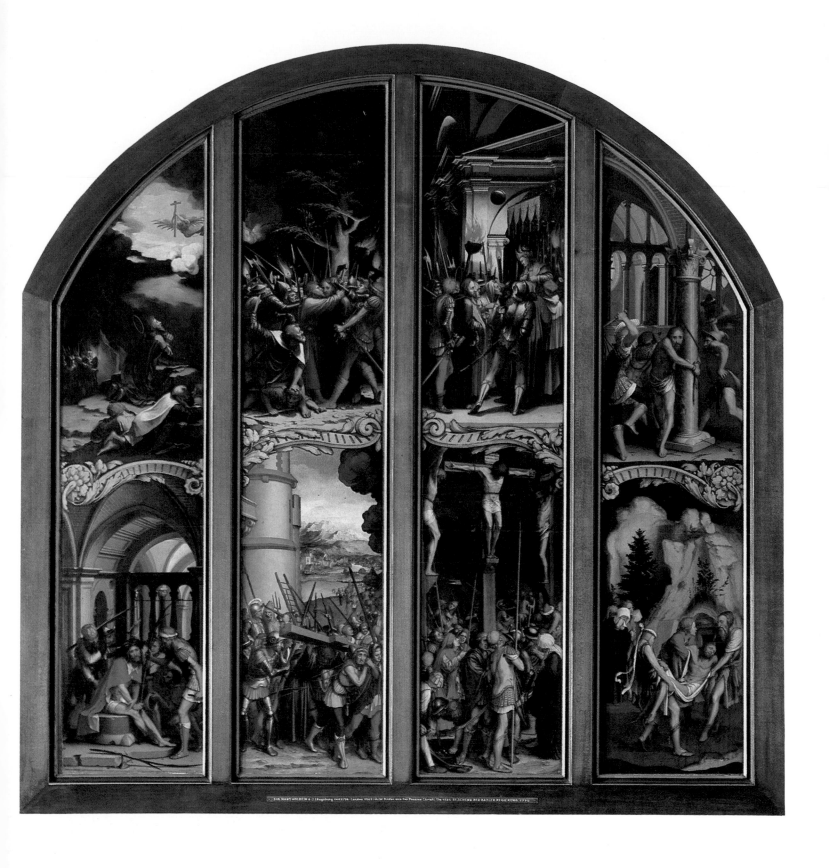

42

The sinister, faceless malevolents surrounding Christ are only distant cousins to the monstrous degenerates Hieronymus Bosch portrays in his versions of this scene. Holbein is adept at mingling observation of the all too human with the inherent drama of the event; the flickering torchlight, the plausibly vehement figure addressing a squirming Pilate, and Christ's calm resignation enthrall rather than terrify. The of the elegantly posed guard in half-armour in the foreground focuses on the tension between the three central figures seen in profile. Despite antique Roman touches in clothing, the red-haired axe-man on the left might have been seen by Holbein on the Basle streets available for hire as a mercenary for military expeditions into Italy. Mercenaries were one of the region's main economic resources at the time; Urs Graf, a contemporary graphic artist, found employment in their ranks when artistic commissions were scarce.

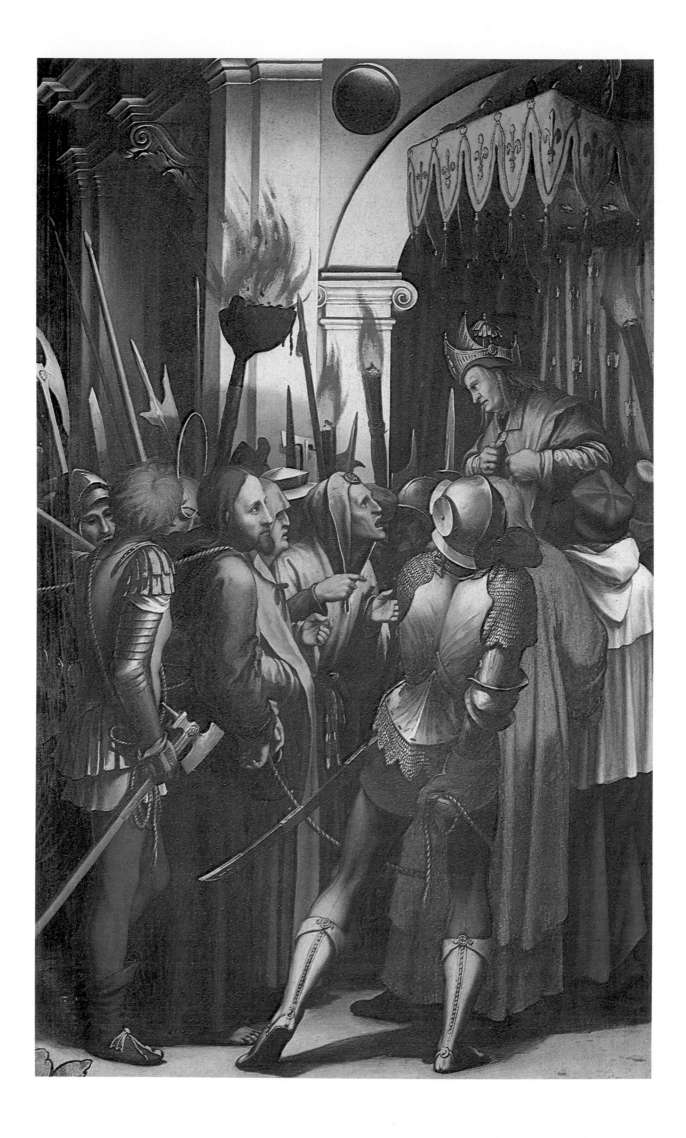

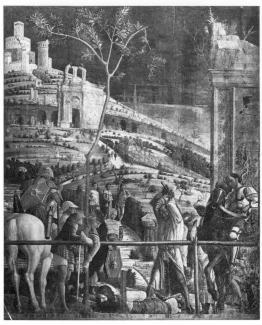

Fig. 17
Andrea Mantegna
The Martyrdom
of Saint James
c.1456. Fresco. Padua,
Eremitani chapel

Here the italianate influences are slightly stronger than in the scene of Christ before Pilate above, though no direct borrowing is observable. Holbein has adapted the smoothly elegant contrapposto stance that Andrea Mantegna had rediscovered in Roman statuary to suggest the nonchalance of the guards, just doing their job. Mantegna's frescoes in the Eremitani chapel at Padua (now damaged) are oblique sources for Holbein's, perhaps through engravings. The parallel placement of limbs, as with the green-cloaked soldier's right leg and the left arm of the guard casting lots, and the antique-style leggings and body-hugging jerkin of the guard in yellow, are southern in design. Otherwise, a sense of northern flurry and activity displaces Mantegna's calm grandeur; the touch of orientalism in the turbanned figure to the right may imply Venetian influence (through artists like Vittore Carpaccio) and contemporary chain-mail, armour and axes underpin the stark emotionalism of the figure of Saint John, with his fists clenched, behind the grieving Virgin; a combination that balances the dourly painful chiaroscuro treatment of the crucified trio overhead.

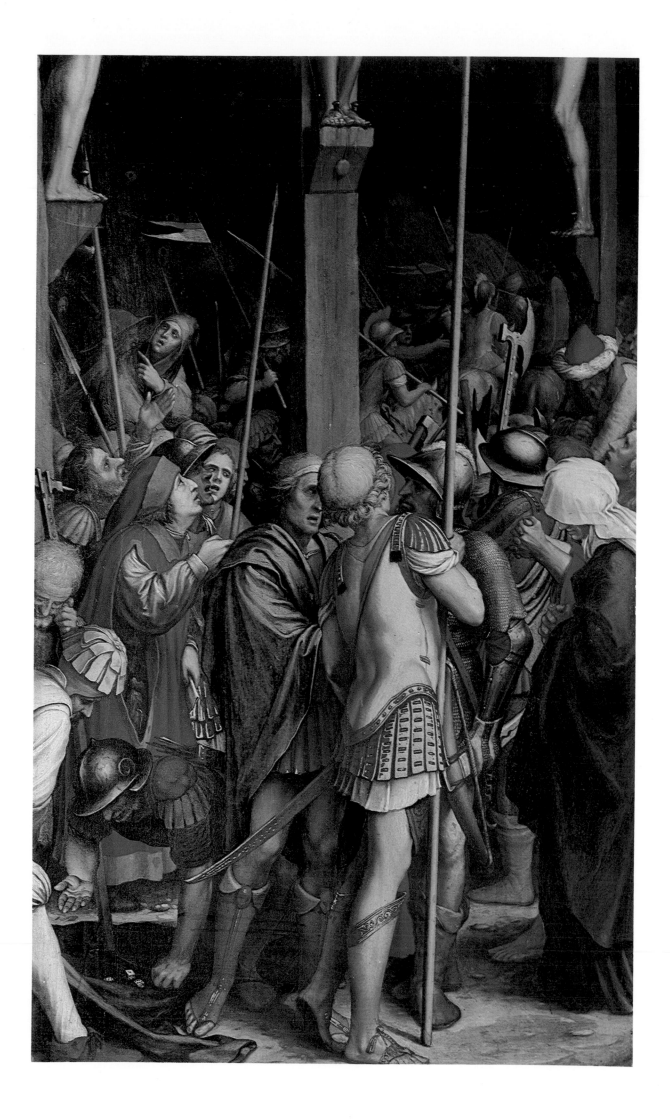

The Body of the Dead Christ in the Tomb

1521. Oil on wood, 30.5 x 200 cm. Basle, Öffentliche Kunstsammlung

Portraits apart, this is perhaps Holbein's most striking image. Since Dostoevsky's observations in the nineteenth century, which dwelt on the forebidding aspects of physical decay and bodily corruption, the painting has been seen as the product of a mind steeped in the apocalyptic horrors that were unleashed by the first phase of the Reformation. But what is known of Holbein's phlegmatic interpretation of the human condition belies this interpretation. Modern authorities suggest that Holbein intended to stress the sheer miracle of Resurrection and its imminence, since the minutely-observed level of decay in the gangrenous wounds suggests that we see Christ's body three days after death.

An inscription in brush on paper, 'IESUS NAZARENUS REX IUDAEORUM', borne above the painting by angels holding the instruments of the Passion, precludes its use as a predella panel (at the base of an altarpiece), as does our viewpoint of the body. Instead, a role as an object of contemplation, a reminder of Christ's sufferings and mortification and his subsequent triumph, is suggested. Such practices flourished from the late middle ages and account in part for the many representations of the dead Christ from Lombardy (the Bellinis in Venice also produced several). Mantegna's famous version (Fig. 18) grapples with artistic as well as religious problems in its dramatic foreshortening, which are not fully resolved. By contrast, Holbein's draughtsmanship appears masterly.

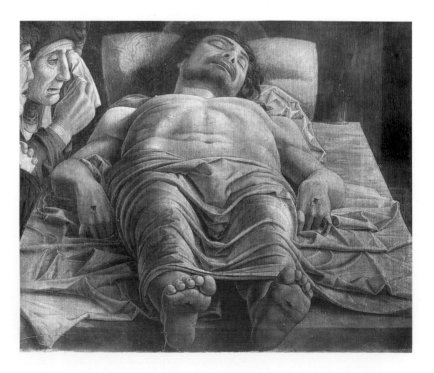

Fig. 18
Andrea Mantegna
The Dead Christ
c.1500. Oil on canvas,
66 x 81 cm. Milan, Brera

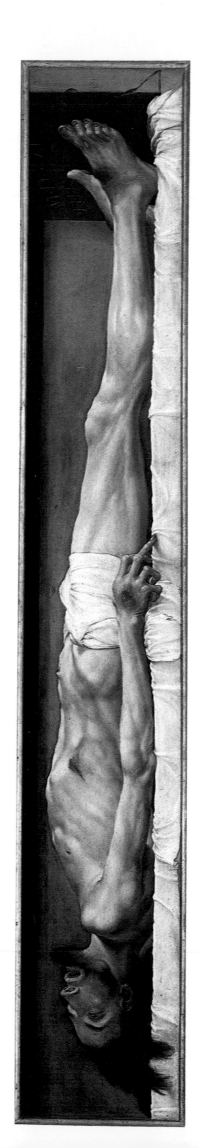

Noli Me Tangere

1524. Oil on wood, 76.8 x 94.9 cm. Royal Collection, Hampton Court

This Renaissance subject allowed the artists to explore the theme of human emotion proffered and supra-humanly rejected. Holbein's style is subtly different here from his other religious work of the early 1520s. It is more graceful, if somewhat awkwardly composed, and has an air of mystery.

The Christ is akin to the melancholic long-faced figure in the *Passion*, but the chiaroscuro in the figures and their grace suggests some Leonardesque influence, if only second-hand. The profile of Mary Magdalene, the elegant phial she holds and her twisting pose are reminiscent of the figure style current in France, which Holbein visited at this time searching unsuccessfully for employment. It is probable that, adapt their conventions as he might, the robust, realist vein in Holbein seemed archaic to the sophisticates at King Francis I's court, who were to find the italian mannerism of Rosso Fiorentino much more to their taste in the following decade.

The emphatic drama of Holbein's account can be contrasted with the more elegiac quality of light, the landscape, more tempered poses and slighter figures in Titian's rendering (Fig. 19).

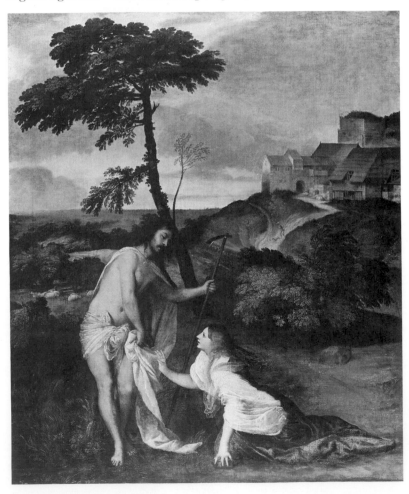

Fig. 19
Titian
Noli me Tangere
c.1512. Oil on canvas,
108.6 x 90.8 cm.
London, National Gallery

The Artist's Family

1528. Oil on paper mounted on wood, 77 x 64 cm. Basle, Öffentliche Kunstsammlung

The moving combination of resolution and frailty seen in this family portrait is unique in Holbein's production. The introverted mood of the work extends beyond the usual level of reticence in his English portraits, where courtly finery and the dignity inherent in status to some extent shield the private lives of the sitters. The work provokes consideration of the relationship between the painter and his wife, who was separated from him for years at a time, bringing up their four children alone. The strain of this fractured family life may be seen here in the weary resignation of Elsbeth's wan face. The sober colours and emphasis on linear execution (seen in young Philip's profile) are perhaps concessions to what was acceptable in reformist Basle at the time, although elements of the dislocated triangle of the composition and the modelling of the mother's hand on the boy's shoulder are reminiscent of Leonardo's *The Virgin and Child with Saint Anne*, which Holbein probably saw during his visit to France in 1524. The painting's dour background is a later result of cutting out the figures and laying them down on a panel; originally, there may well have been a decorative background as is the case in one copy.

Elsbeth eventually had to sell the work to make ends meet, suggesting abandonment by Holbein as well as official separation.

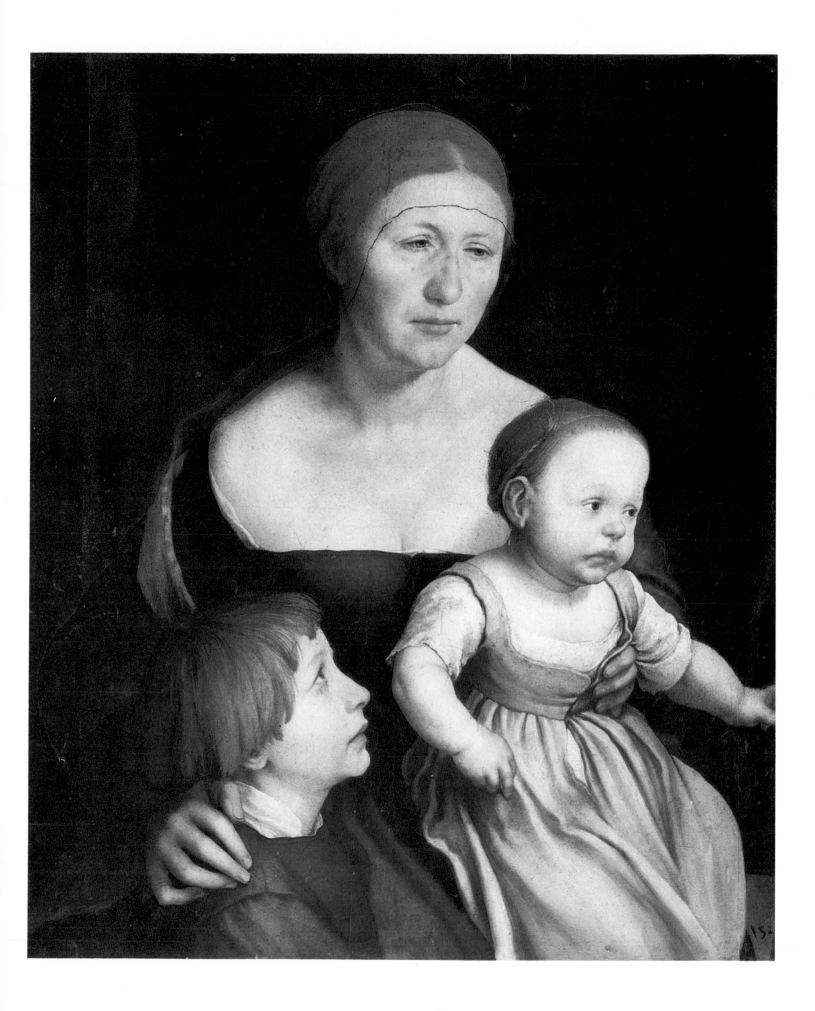

Erasmus

1523. Oil on wood, 43 x 33 cm. Paris, Musée du Louvre

Holbein's greatness is demonstrated in this fine portrait not only in its technical mastery but also in its comprehension and presentation of the salient features of the subject's personality and activity. The scale of Erasmus' bulk within the picture space is prodigious; previously, scholars had been portrayed in book-lined studies, surrounded by the tools of their trade, musing as does Saint Jerome in Dürer's woodcut of 1514, complete with shaggy lion. (Erasmus himself edited Saint Jerome's works, thus identifying with the patron saint of translators.) Saint Augustine was also popularly depicted in a monastic study, as in Carpaccio's appealing image of 1505.

Holbein's treatment is more intimate; to be able to look over the scholar's shoulder at the pen poised on the paper (engaged on the Paraphrase of Saint Mark) is an honour the nervous Erasmus would have granted only to intellectual equals. It has been concluded that Sir Thomas More was the intended recipient of this version: Erasmus was usually posed in a more formal three-quarter view. Such portraits were often exchanged by humanists as tokens of mutual esteem, which explains the considerable number of painted and engraved copies in existence; aspiring scholars would use these to adorn their studies as encouragement to their emulatory efforts.

Erasmus lived through writing and above all, by correspondence; ironically, in 1533 he was to censure Holbein for delaying in Antwerp which was preventing Erasmus' mail being delivered (Holbein being the bearer). Here, as in other portraits of him, we see the great master of North European humanism in his self-appointed role as educational conscience of the age.

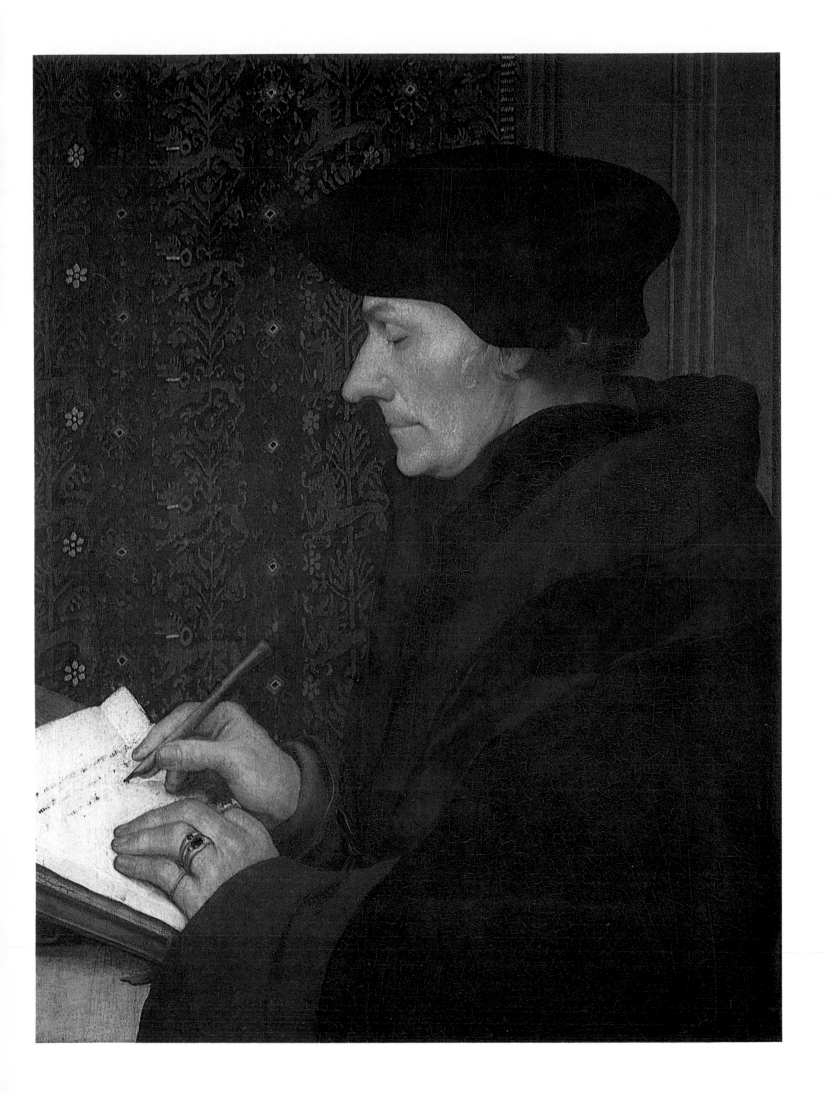

1526. Oil on wood, 35.6 x 26.7 cm. Basle, Öffentliche Kunstsammlung

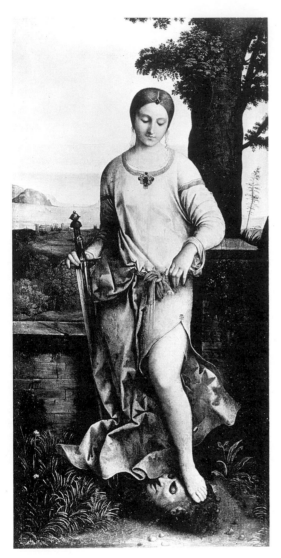

The worldly-wise elegance of pose and expression of this courtesan, combined with the soft and smoky modelling of her features, shows the influence of Venetian painting, which, by the 1520s, was already renowned (and sometimes attacked) for its air of opulent hedonism.

Lais – said to have been the mistress of the ancient Greek artist, Apelles – signifies Mercenary Love, it has been thought that a similarly posed figure in a smaller work entitled *Venus and Cupid* (also in Basle) might be a pendant to this, representing Pure Love. However, although Venetian artists were familiar with the theme of 'Sacred and Profane Love' contrasted, as in Titian's great workof that title, no such conclusion seems possible in Holbein's case.

As Giorgione's *Judith* reveals (Fig. 20), Holbein's sources were pre-eminently the sinuous, well-proportioned figures that Leonardo and Raphael had used for their madonnas (as 'perfect' women) but which had taken on other, less spiritual qualities once they reached Venice. Nevertheless, Holbein's adaptation seems to restore some of the earlier Renaissance innocence and Lais's demure expression belies her supposedly brazen costume. The artist shows greater interest in effectively foreshortening the figure's right arm than in presenting a character of easy virtue.

Fig. 20
Giorgione
Judith
Oil on canvas,
transferred from panel,
144 x 66.5 cm.
St Petersburg, Hermitage

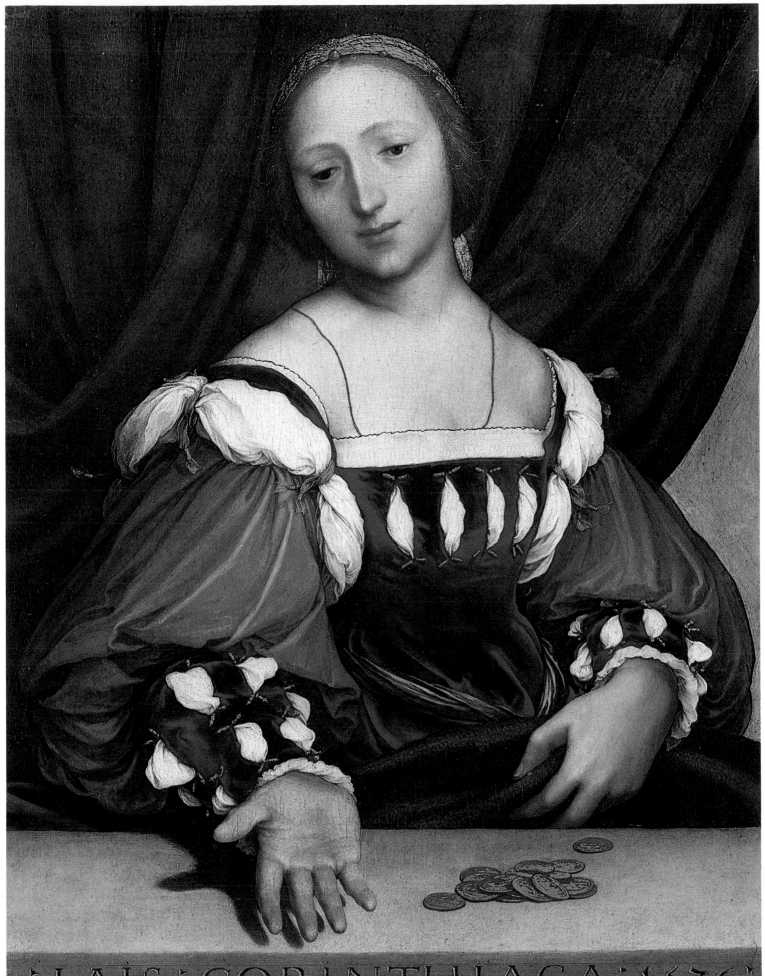

:LAIS:CORINTHIACA:1526:

1526. Oil on wood, 146.5 x 102 cm. Darmstadt, Schlossmuseum

Fig. 21
Portrait drawing
of Anna Meyer
1516. Black and
coloured chalk.
Basle, Öffentliche
Kunstsammlung

The *Meyer* or *Darmstadt Madonna* is the last, most famous and most effective of Holbein's great religious works, above all in its depiction of individual human identities combined with spectacular spatial control and illusionism – as exemplified by the ruckled carpet.

This is a *Schutzmantelbild* (a 'Virgin of Pity' painting), in which the donor, Jakob Meyer, invokes and gains divine protection for himself and his family. Chastened by worldly failure and disgrace (see Plate 2), Meyer no longer staunchly outstares the world but has his eyes fixed on other realms in meditative intensity. This introspection is echoed by his wives – the enigmatic enwrapped profile of his first, Magdalena Baer (who had died in 1511) and Dorothea Kannengiesser (see Plate 3). Before them kneels Anna, the only surviving child, whose portrait drawing in chalk shows her with free-flowing hair (Fig. 21). Holbein repainted her hair tied in a band after her engagement.

In front of Jakob, in a Raphaelesque triangular pose deployed with subtlety and skill, his two deceased sons are depicted. The baby, with curly blonde hair and pudgy cheeks, has affinities with the Leonardo type. Also Leonardesque is the prowess shown in the foreshortening of the Christ-child's extended arm, and the naturalness of the baby's pose, which recall *The Virgin of the Rocks* (Fig. 22).

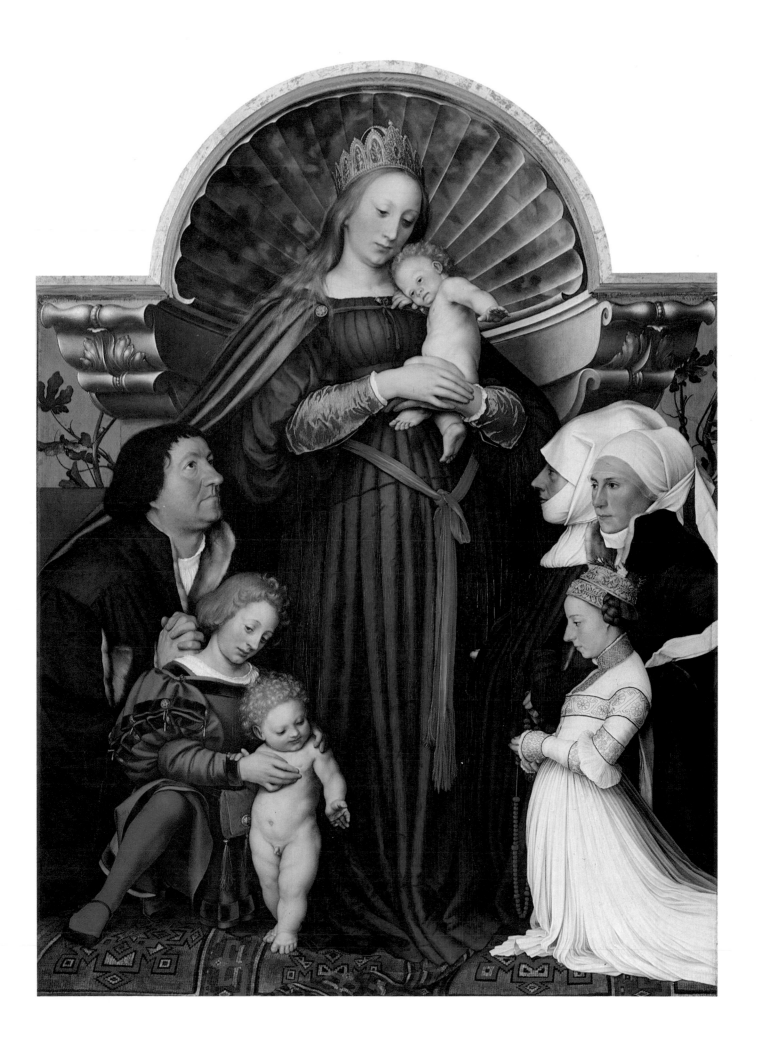

Fig. 22
Leonardo da Vinci
The Virgin of the
Rocks (detail)
c.1506-8. Oil on wood,
189.5 x 120 cm. London,
National Gallery

The presentation of the Madonna and Child is a triumph of illusionism that ranks with the achievements of Van Eyck in Flanders a century before. The play of light over the fluting of the architectural shell behind the two figures carves out the space into which the delicately shadowed crown, hair and face of the Madonna are set. There is no Raphaelesque regularity in the Madonna's features – as with most northern madonnas, a specific model was used, a friend of Holbein's, one Magdalena Offenburg, who also posed for the *Lais* (Plate 12) and whose lifestyle, ironically, was not considered blameless.

However, the compelling physical presence and credibility of the figures is the result of artistic means alone; the twisting of the child's body emphasizes the weight the Madonna's arms must carry, and Christ's projecting feet and the foreshortening of his own and his mother's arms stress the space his torso occupies. The combination of warm green and gold also brings the Madonna forward against the neutral tone of the stonework.

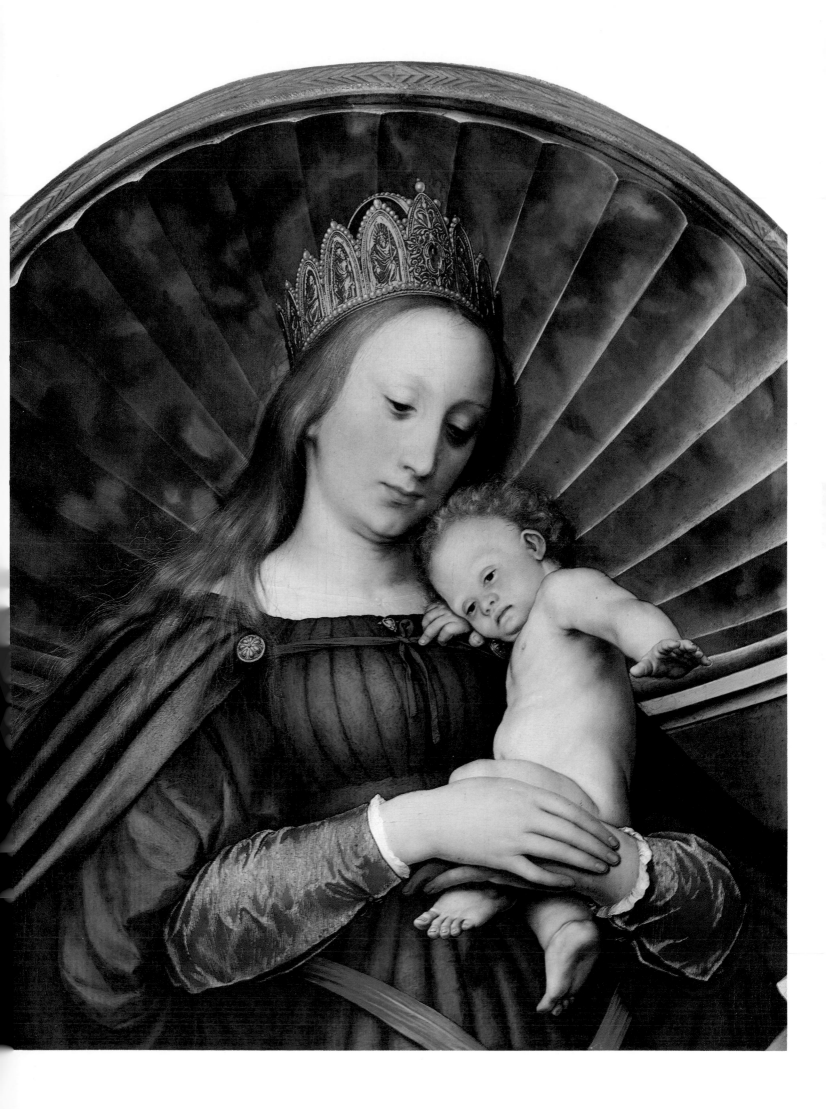

Jakob Meyer's unusual stipulation that the artist include his deceased first wife Magdalene in the painting was the result of the death of Meyer's two sons during Holbein's first English absence: he decided to include all members of his family, living and dead, rather than omit any individual. Holbein brilliantly resolved the problem of tactfully integrating Magdalena's portrait into the group. The use of the profile and her retiring position at the back avoid direct eye contact, and the swathing of her face in cloth ensures that her features – which Holbein had never seen – do not seem vapid in comparison to the forceful portrayals of the rest of the family.

The great skill and delicacy of the detailing of Anna's hair-band, catching the translucent light over the pearls, recalls the attention to detail of the old Flemish masters and their early explorations of the powers of oil paint. In this private work for the Meyer chapel at Gross Gundeldingen Holbein achieved a combination of piety and grandeur, and interaction between the human and divine, to rival that of Van Eyck himself.

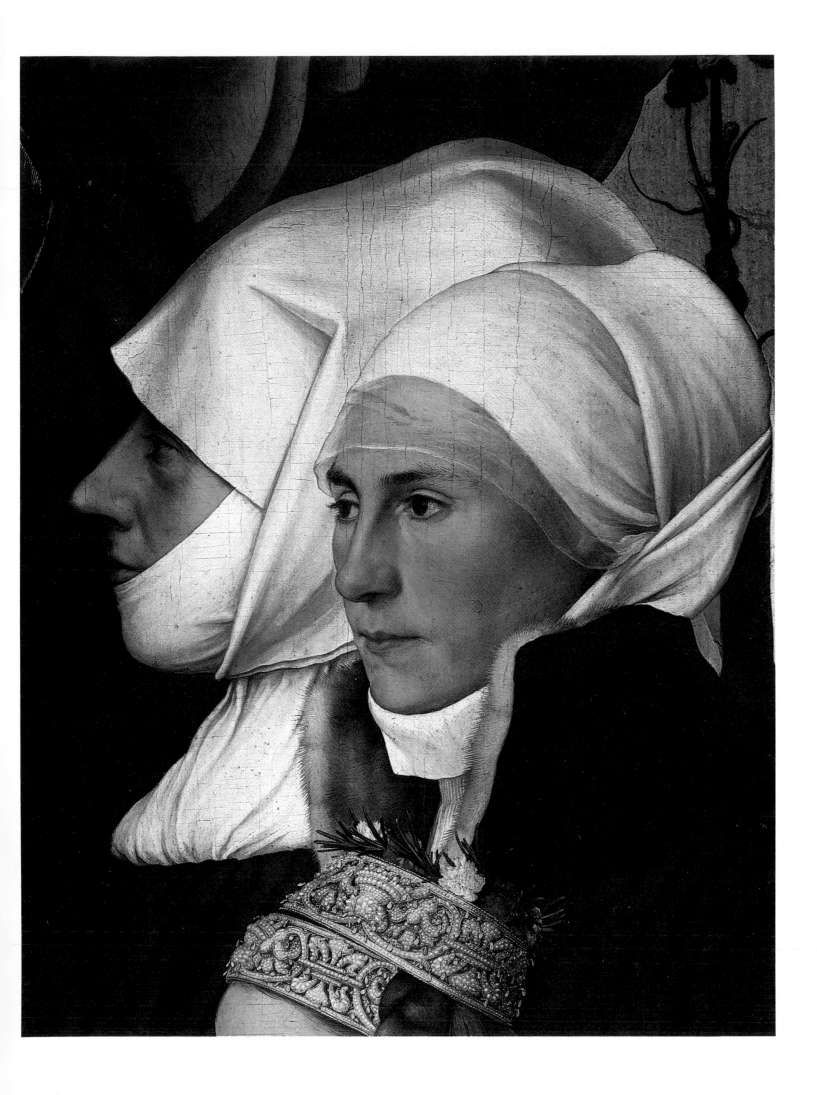

The Ambassadors

1533. Oil on wood, 207 x 209.5 cm. London, National Gallery

From 1532 until he became firmly ensconced at Henry VIII's court in 1536, Holbein was dependent on the patronage of the German Steelyard merchants. His allegorical works for them (see Plate 31) enabled him to use emblems with increasing fluency, as is very apparent here, in a tour de force aimed at an audience beyond Holbein's German circle.

This ambitious work alludes to the preoccupations of the two diplomats it portrays in the fraught year of 1533: Jean de Dinteville, on the left, was in England on a mission for Francis I apropos of Henry's quarrel with the papacy over his marriage to Anne Boleyn in May. De Selve (later Bishop of Lavaur) probably gave his friend diplomatic and moral support. The painting was also a means by which Holbein might impinge on court circles as a serious student of religious reform and tolerance, then crucial issues in England (and after his experiences in Basle, crucial to Holbein too). In this sense, the painter is in league with his sitters.

The broken-stringed lute (symbolic of discord) and Luther's translation of *Veni Creator Spiritus* present an appeal for spiritual guidance in resolving the nation's religious and diplomatic tangles. The floor-pattern is close to that of England's only mosaic floor, by the shrine of Saint Edward the Confessor in Westminster Abbey, and perhaps signifies nationalism and religion effectively combined.

References to the Last Things abound; the artful and mysterious elliptical skull (a popular manneristic design-feature at this time) and the death's head on de Dinteville's cap-badge, underline the power and seriousness of the two men's mission, while darkly indicating the equitable end of all human effort.

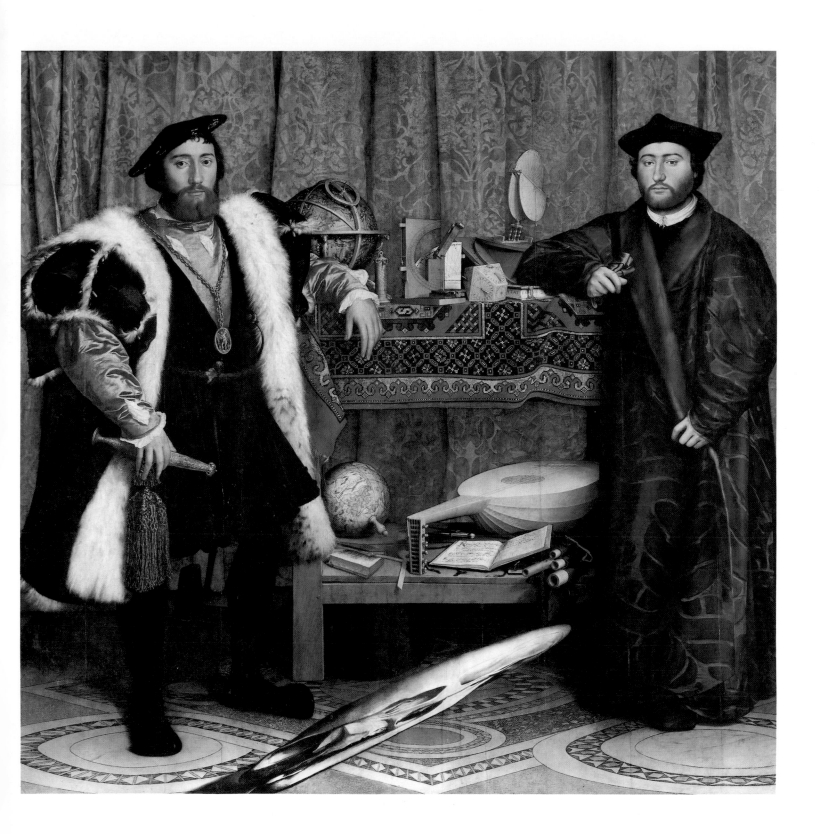

No preparatory drawings survive for *The Ambassadors*, nor is it clear how the commission for the work came about. Only the character and employment of the sitters are known. The identification of Jean de Dinteville has been aided through a portrait drawing by Jean Clouet of about the same date as the painting.

Though Holbein's style changed little over the course of his career, the subtlety and opulence of the colours in this work are different from the starker tonalities he used in Basle. The green backdrop and the pink slashed shirt of the diplomat add a zest which is further enhanced by the juxtaposition of different textures of silk and woven cloth. Like Titian, Holbein was an assured painter of fur (a crucial ability for a court painter) and the contrast between the soft ermine and the glistening metal chain serves as a rich textural counterbalance. The intense realism Holbein achieved here was due to his prodigious visual memory and refusal to let either draughtsmanship or the application of paint alone dominate the execution.

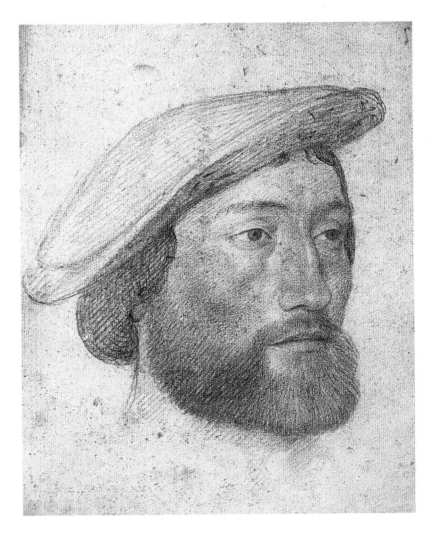

Fig. 23
Jean Clouet
Portrait of Jean
de Dinteville,
Seigneur de Polisy
c.1533. Black and red
chalk, 25.1 x 19 cm.
Chantilly, Musée Condé

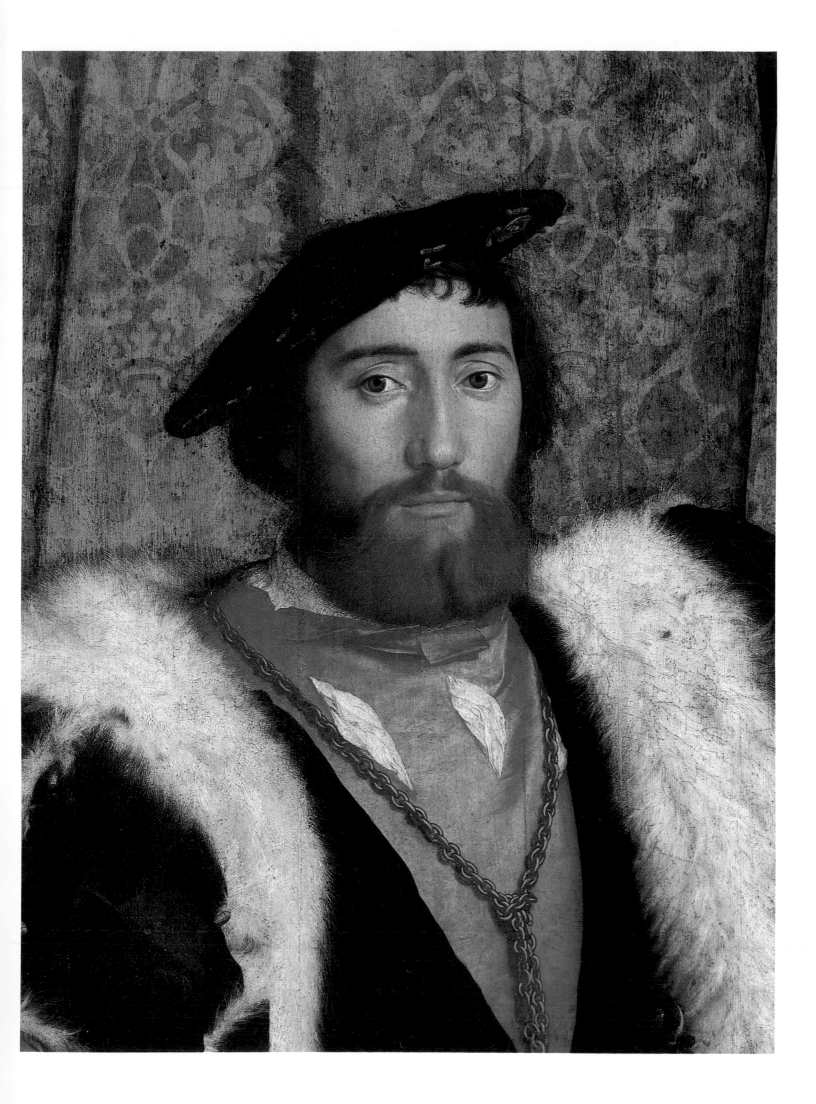

Sir Thomas More

1527. Oil on wood, 74.2 x 59 cm. New York, The Frick Collection

Along with Colet and Linacre, More was one of the moving spirits of the revival of learning and letters in the early years of Henry VIII's reign. The King himself seemed to presage a new civilized age and was keen to attract foreign artists and intellectuals to embellish his extrovert court; Erasmus himself was tempted to stay in England but finally refrained.

Holbein presents the public figure, robed in authority (for all his saintly reputation More was ferocious enough to condemn heretics to be burnt.). The determined severity of countenance betrays little of the retiring scholar, although this is suggested in the figure's slight stoop. More was certainly concerned with the impression he made, insisting on having the flamboyant cuffs on his official costume replaced by ascetic plain ones.

The fine drawings made prior to the painting show a new delicacy of touch prevalent in the artist's manner after his visit to France; greater attention to the texture of material, fur and velvet was the painterly consequence. The emergence of complementary red and green tonalities to stress spatial values is apparent, but is more straightforward here than its usage in Holbein's second English period.

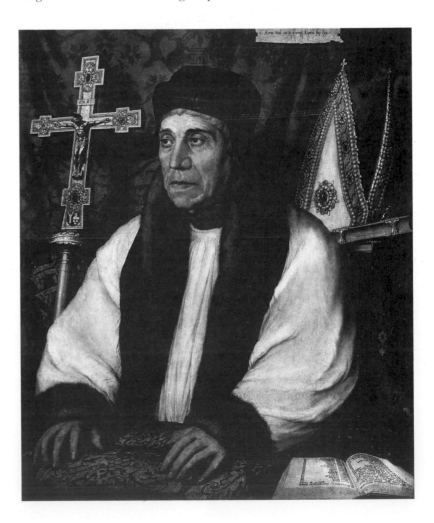

Fig. 24
William Warham, Archbishop of Canterbury
1528. Oil and tempera on oak panel, 82 x 67 cm.
Paris, Musée du Louvre

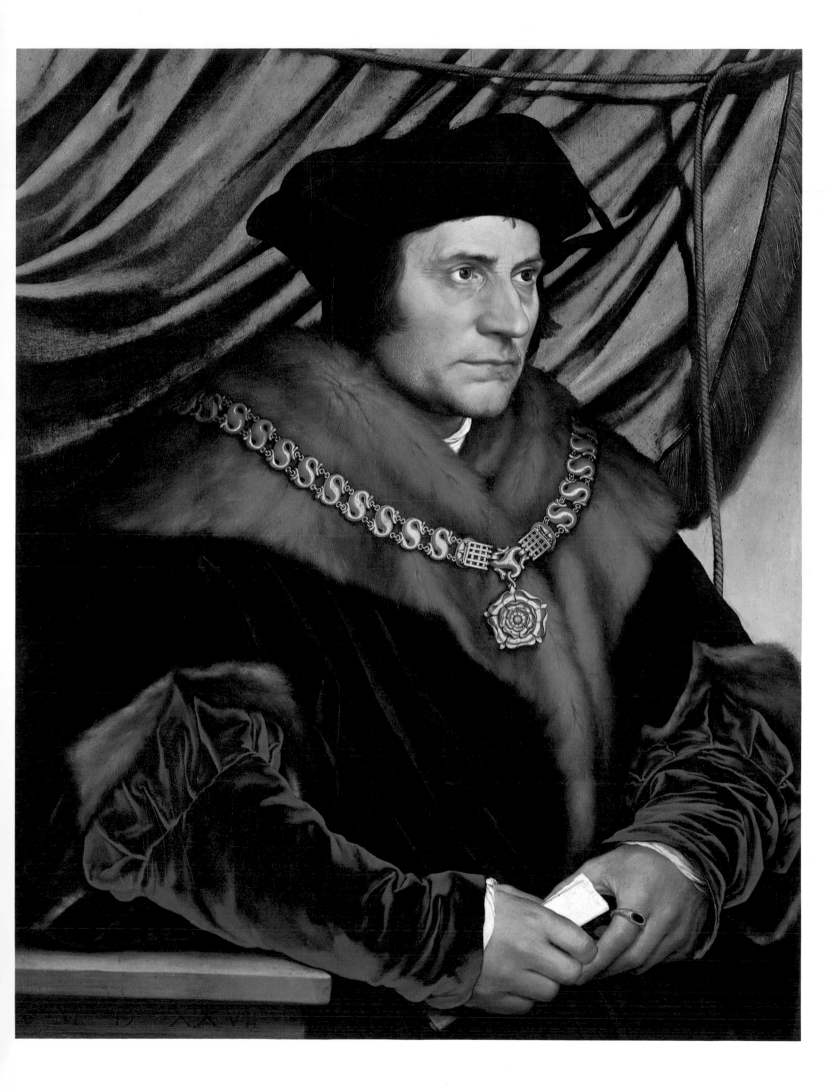

Unknown Lady with a Squirrel and Starling

c.1528. Oil on wood, 54 x 38.7 cm. London, National Gallery

This work (until recently in the Cholmondeley collection) demonstrates many of the features found in Holbein's work from his first English visit; the thoughtful, reserved expression of the sitter, less direct than in many later works, and the use of plant motifs (see Pate 21) to animate an otherwise flattened background. The lady's anonymity (she was most probably English and of the More circle, whose members were notably fond of animals) undoubtedly focuses attention on the meaning of the squirrel and starling's presence; these may have been intended as references to her name, or as living tokens of the family coat of arms. It is known that squirrels were often kept as pets at this time, while starlings are biddable companions. After the painting's recent cleaning, the squirrel's gleaming eye and soft fur have revealed Holbein to be as effective an animal painter as his German contemporary Hans Hoffman. Holbein's particular structural skill is evident in the way the squirrel's curling tail echoes the vine stem in the background, itself reminiscent of the Amerbach portrait (Plate 4).

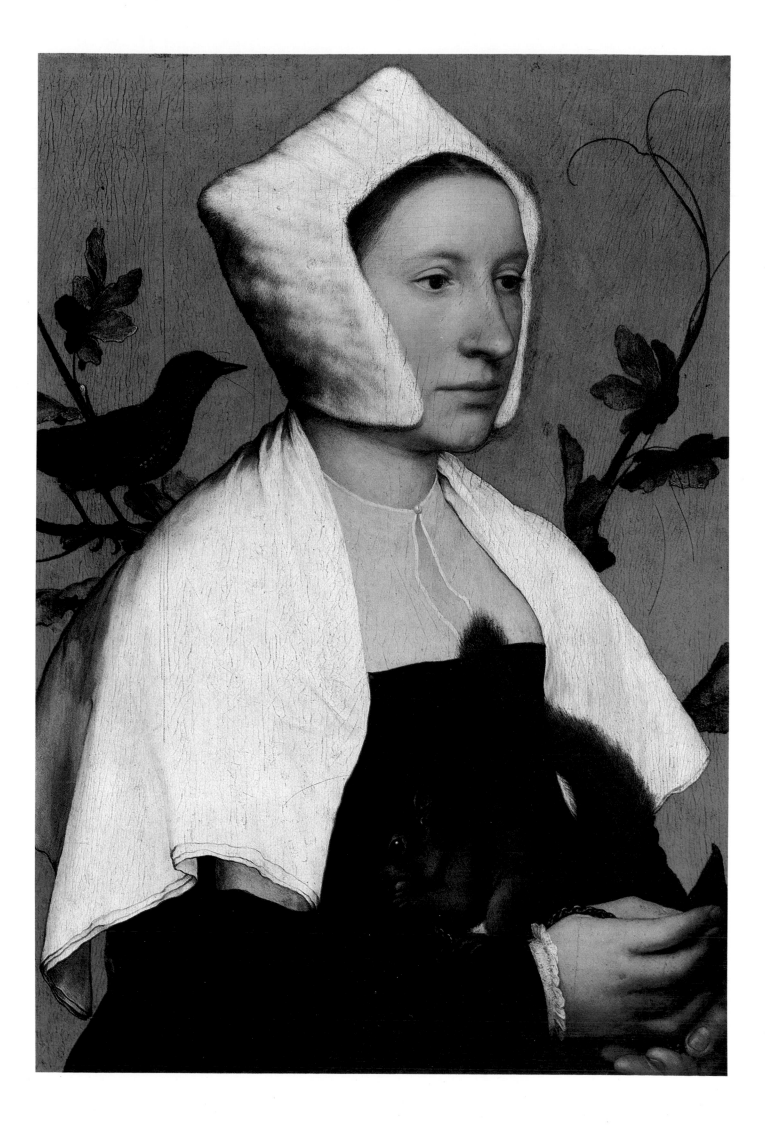

Sir Henry Guildford

1527. Oil on wood, 81.4 x 66 cm. Windsor, Royal Collection

Sir Henry Guildford (1489–1532), two years older than Henry VIII, was a great favourite of the King, ending his career at court as Comptroller of the Royal Household, whose baton of office he holds. He also wears the Order of the Garter, awarded him in 1526. He was a strong proponent of religious reform.

In comparison with the preparatory drawing held at Windsor, the sitter appears sterner and more conscious of office; worldly power emanates from his bulky figure, which swamps the background in the way Henry himself was also to do (see Plate 36).

Sensitive though the modelling and shading of the face are, they reveal less empathy than is evident in the portrait of More (Plate 18). A trace of latent tension or paranoia, akin to that felt in Florentine mannerist works gives an edgy quality to the apparently self-assured form, enhanced by the brittle lighting at the top left of the picture which brings the vine and its tendrils into prominence. The badge on Guildford's cap bears geometrical forms which are also found in Dürer's *Melancolia 1* (1514).

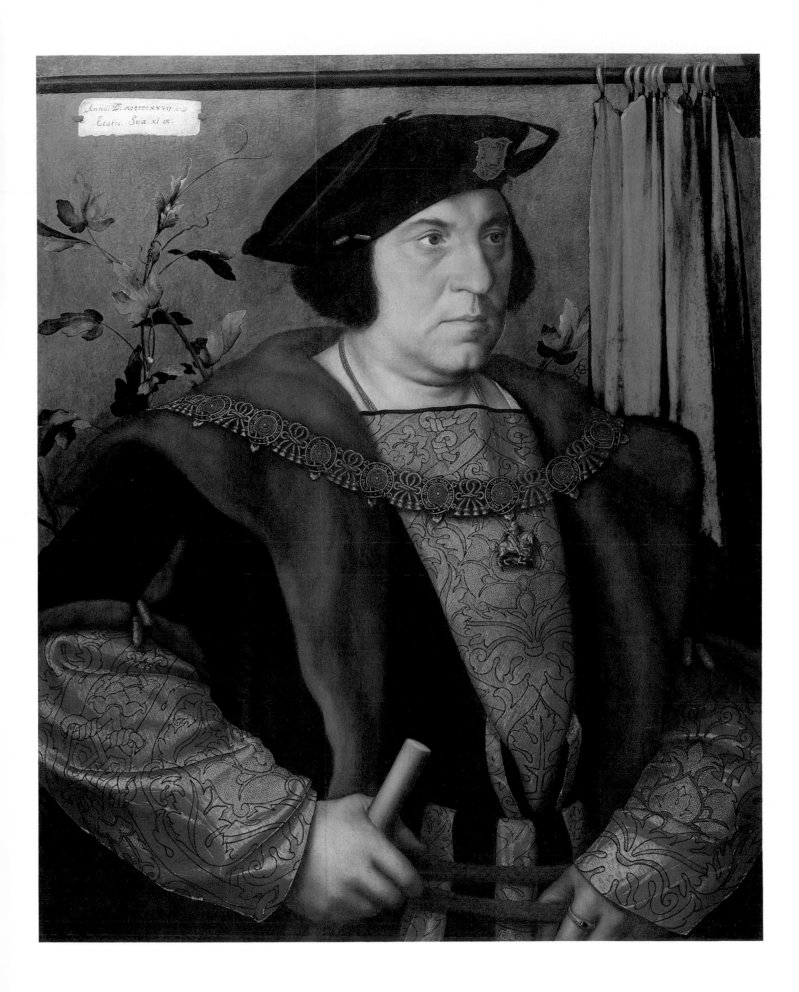

21 Lady Guildford

1527. Oil on wood, 80 x 65 cm. St. Louis, City Art Museum

The preparatory drawing for this portrait is still held in Basle, which may indicate why the harsher lighting and greater linearity of the painting recalls Holbein's earlier European style. In comparison with the More family portraits, there is a stark flatness in the modelling of the plump sitter, whose figure is less comfortably integrated with the background. There is less interest in the texture of material (especially in the head dress), and awkward elements such as the grotesque head on the pillar seem to parody Lady Guildford herself. Holbein resorts to architectural as well as natural forms to rein in the composition, but despite the iron stanchion at the back and the receding perspectival column and pillars, ambiguities in space are unresolved at the far left and bottom right. Only the depiction of the sitter's arms and hands seems to have engaged the artist's full attention and powers.

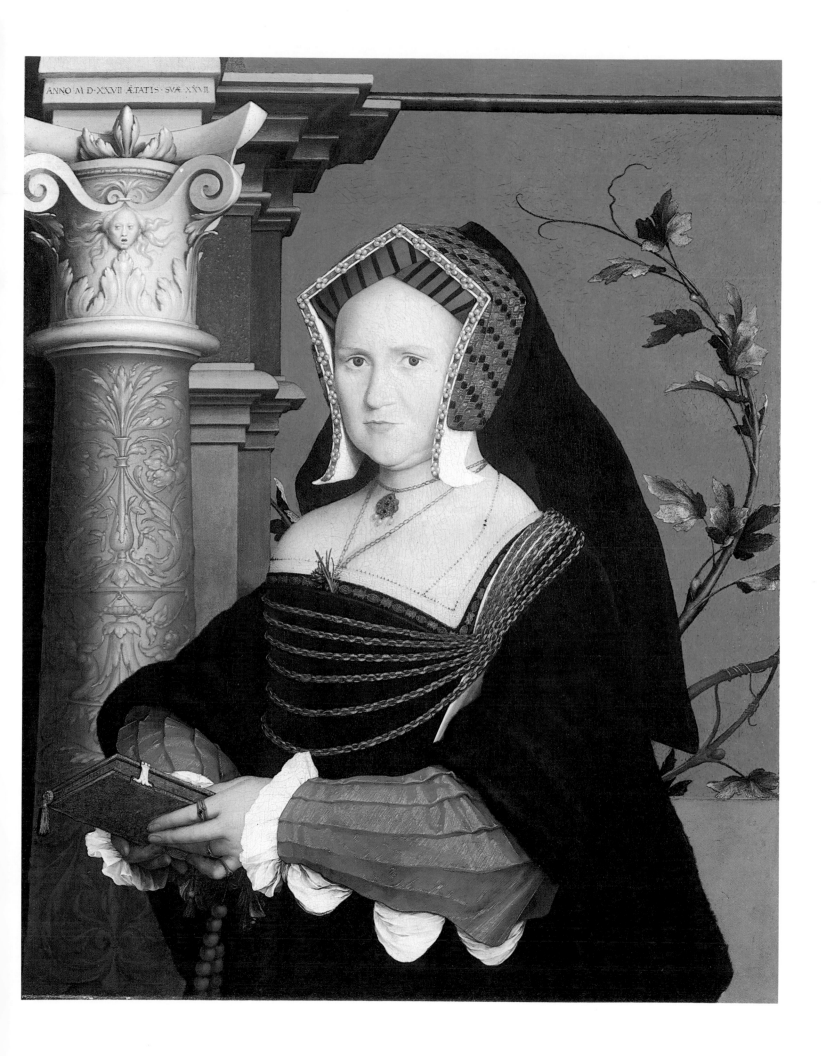

Georg Gisze of Danzig

1532. Oil on wood, 96.3 x 85.7 cm. Berlin, Staatliche Museum, Gemäldegalerie

On oak panel, like the vast majority of such portraits, this depiction of the Hanseatic merchant ushers in a new phase of work from the serious-minded and determined Holbein who returned to England in 1532, eager to gain commissions. In this respect, the Gisze portrait has affinities with the *The Ambassadors* of the following year (Plate 16). Both have the softer shadowing, more varied and complex backgrounds, overflowing with illusionism and *trompe l'oeil* and references to mottoes and philosophical themes, which were largely absent from the more straightforward productions of the 1520s. Among the details Holbein assembles are the sitter's name, on the wall to the left, with his motto 'No Pleasure without Regret', letters to Gisze hung over a rail to the right and, on the brightly-covered table, the artifacts of a merchant's office, with coins visible in a metal box.

As in Dürer's portraits (see Fig 2) Gisze himself stares back at the viewer, in contrast to the artist's earlier preference for the avoidance of eye contact. This allows the figure of the merchant to dominate, as a living presence, the otherwise overbearing crowd of inanimate objects. The exquisite finesse in the treatment of the vase and pinks (whose colour repeats that of the silk jacket) is amongst Holbein's most skilled and spirited achievements.

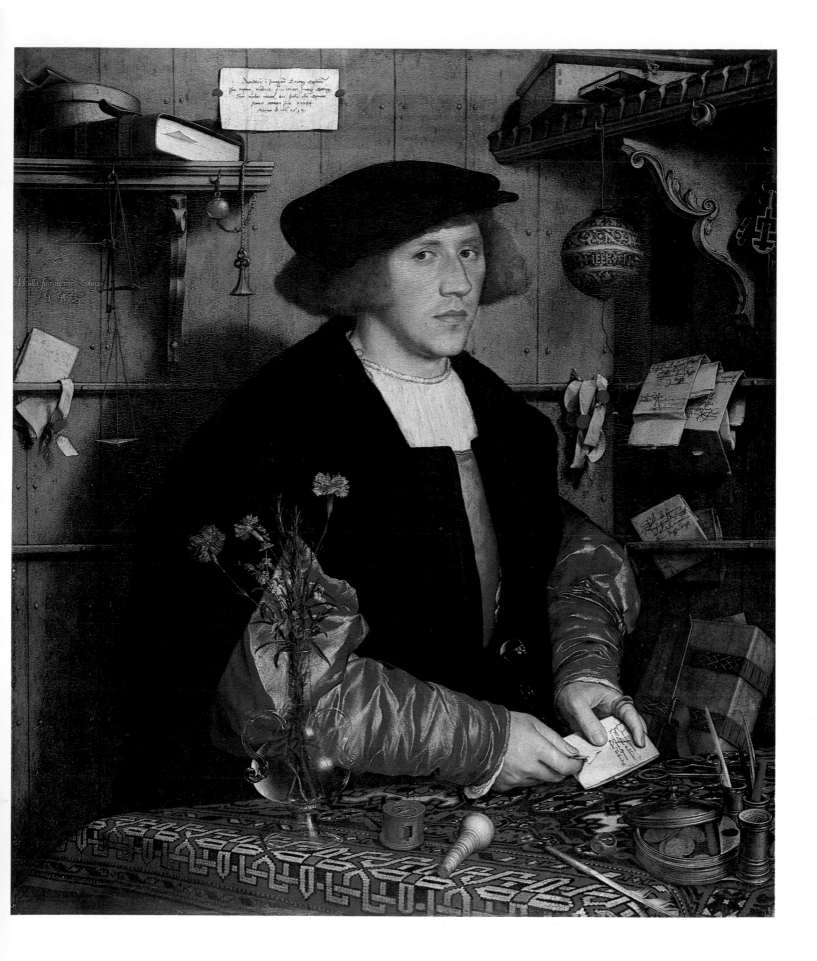

Charles de Solier, Sire de Morette

c,1534. Oil on wood, 92.7 x 75.2 cm. Dresden, Staatliche Gemäldegalerie

The imposing figure of de Solier, which looms across the entire width of the panel (increasingly a feature of Holbein's work from the 1530s) and confronts the viewer with the stern gaze of direct authority, was to be a prototype for the more flamboyant depiction of Henry VIII a few years later.

Instead of Henry's ostentation, the Frenchman, who replaced Jean de Dinteville as the envoy in London, is depicted as a sombre, businesslike figure, who grasps his ceremonial dagger with a gloved hand. The brooding colours – the unusual dark green, the predominantly black costume worn by the diplomat, made all the more striking by the blocks of white in the sleeves, all add to the portentous impression, an effect much sought after by contemporary Italian mannerists like Bronzino. De Solier's residence in England was brief; the break with the Church of Rome was by this time a *fait accompli*, and little remained of the nervous excitement that can be detected behind the symbolism of *The Ambassadors*. Weiditz' carved portrait of the diplomat (Fig. 26), which also presents a bulky, masterful figure, attests to the accuracy of Holbein's depiction.

Fig. 25
Christoph Weiditz
Portrait of Charles de
Solier, Sire
de Morette
Obverse of boxwood
medallion. London,
Victoria and Albert
Museum

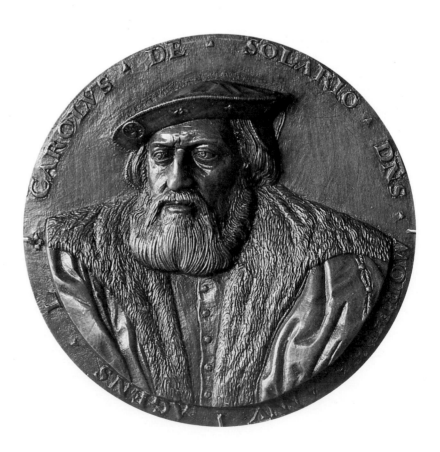

Robert Cheseman

1533. Oil on wood, 59 x 62.5 cm. The Hague, Mauritshuis

Cheseman (1485-1547) was an influential figure in Middlesex, where he was responsible for marshalling levies. Along with other minor figures at court, many of whom were to rise with the fortunes of Thomas Cromwell in the 1530s, Cheseman was the sort of patron on whom Holbein concentrated during the first few years of his second English sojourn. Such clients were less in evidence once Henry and his royal entourage had adopted 'the Apelles of our time'.

These English sitters had more limited intellectual aims in mind for their portraits than the foreign merchants or ambassadors in London. The need for clear, effective portrayal, shorn of symbolism (and expensively painted detail) perhaps accounts for the innovatory use of the information about the sitter, that floats in gold lettering on the blue background, a feature more familiar in miniatures. The artist's regressive abandonment of spatially interesting, illusionistic backgrounds may be another indicator of the undeveloped taste of English clients – a full native understanding of perspective construction did not arise until Inigo Jones' theatre-design work around 1615. The very fine portrayal of the falcon shows Holbein's great power in observing nature; the bird's presence, signifying Cheseman's wish to show his social status, neatly serves to illustrate human nature.

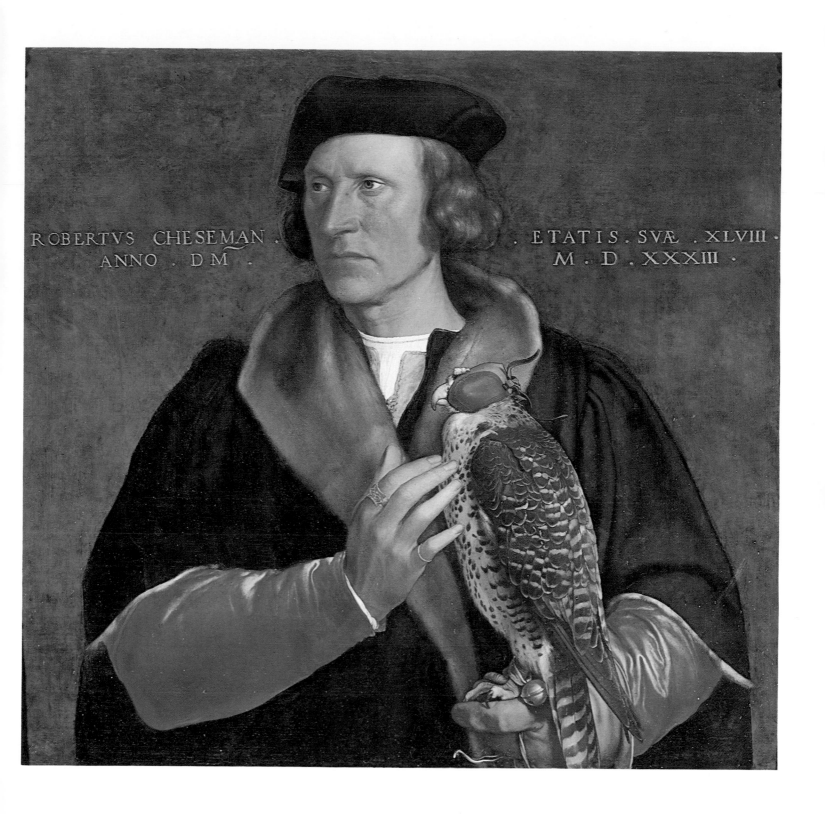

ROBERTVS CHESEMAN . . ETATIS . SVÆ . XLVIII .
ANNO . DM̃ . M . D . XXXIII .

Nicholas Kratzer

1528. Oil on wood, 83 x 67 cm. Paris, Musée du Louvre

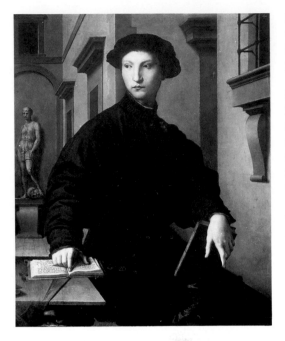

Fig. 26
Bronzino
Portrait of Ugolino
Martelli
Berlin, Staatliche Museen

Kratzer (1497–c.1550) was a native of Munich and a friend of Holbein, who came to England in 1516 and was employed by both More and Cardinal Wolsey (whose downfall occurred a year after the portrait was painted). Kratzer remained in England until his death.

The painting is pivotal in many respects. Despite being a product of his first stay in England, Holbein developed the allusive style of illustrating his sitter's career (as a maker of mathematical and geometrical instruments) to new levels of coherence. Although a display of similar items was to recur in *The Ambassadors*, there they are passive witnesses of mental concerns, while the refreshing directness of Kratzer's practical involvement means that his character is not buried by the artist's determination to include convincing still-lives.

Compared with the Guildford portraits, a new mastery is evident, in the subtlety of lighting, the elegant range of cream, brown and black tones in the pattern of instruments against the wall, and in the presentation of Kratzer's idiosyncratic heavy-lidded gaze. It is revealing to contrast this humane mood with the archly aristocratic tone of Bronzino's *Ugo Martelli* (Fig. 26).

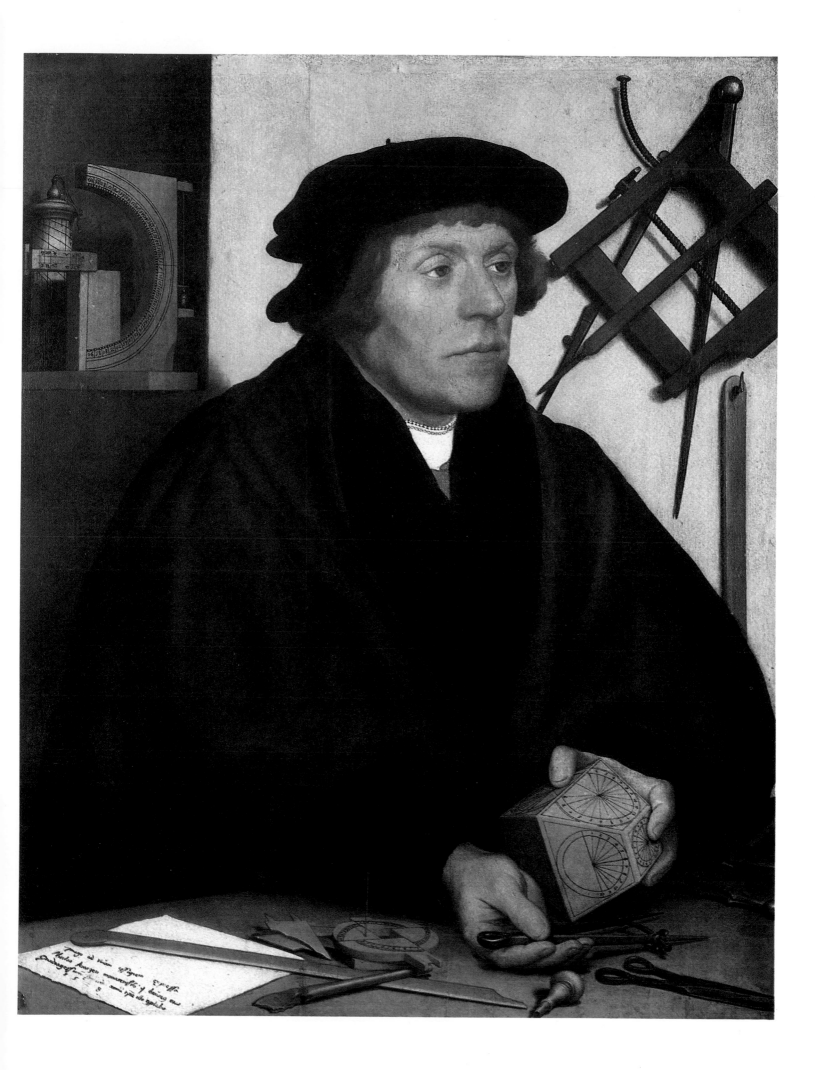

Derich Born

1533. Oil on wood, 60.3 x 45 cm. Windsor, Royal Collection

Like Gisze (Plate 24) and Kratzer (Plate 25), Born, a native of Cologne, was a natural ally for Holbein as a fellow-foreigner in England. Their affinity led the artist to give of his best in this portrayal. A member of the German Steelyard, Born's name occurs in documents relating to supplies of material to the government for the suppression of the northern revolt in 1536. Like many of Holbein's associates during his second stay in England, Born was a reformist. He is also cited in the Hanseatic League's documents between 1542 and 1546.

At first glance, the work relates to the period 1526-8, with the familiar vegetation catching gleams of light in the background; but the bulky form close to the picture-plane is more imposing than that of More (Plate 18) and the direct gaze, coolly appraising the viewer, is also a characteristic of the artist's later style.

The pose recalls Titian's *Gentleman in Blue* (also called '*Ariosto*'), though the execution is less painterly and comes nearer Florentine mannerist smoothness than Venetian *brio*.

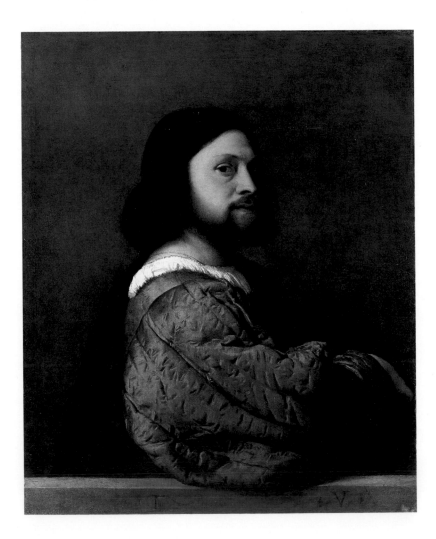

Fig. 27
Titian
Gentleman in Blue
(also called 'Ariosto')
1511. Oil on canvas,
81.2 x 66.3 cm.
London, National Gallery

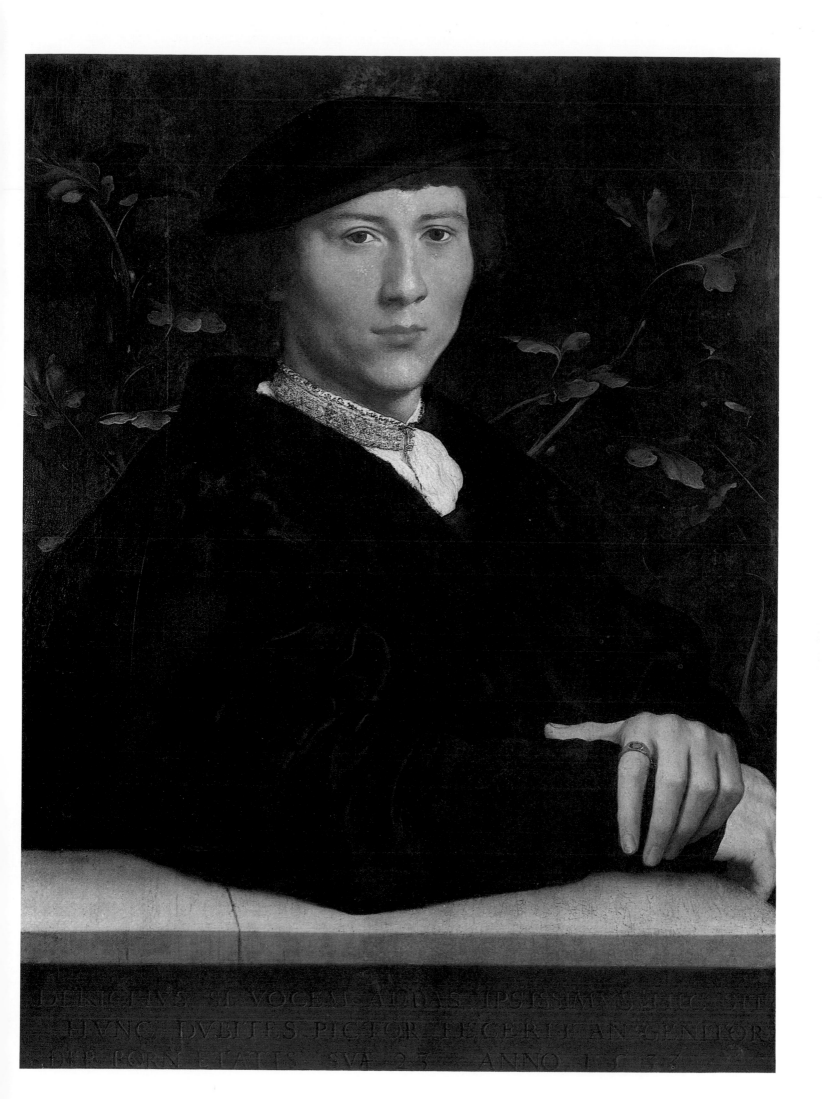

Unknown Gentleman with Music Books and Lute

c.1534. Oil on wood, 43.5 x 43.5 cm. Berlin, Staatliche Museum, Gemäldegalerie

The painting's similarities with other works dating from the early 1530s have led to the supposition that the sitter was a leading musician at Henry VIII's court. The king was a keen musician and amateur composer and rewarded such figures well; to be afforded the destinction of a Holbein portrait could be seen as an official seal of approval. The sitter's employment demonstrates the range of clientele to whom Holbein now catered.

Time has not been kind to this work, however, much of whose detail has been destroyed by overzealous cleaning. The green background is that of the underpainting – hence its unusually harsh tone – and definition on the lute is vague. It is to be expected that writing was originally visible on the score, which may have given the identity of the sitter (once thought to be Jean de Dinteville).

As in Plate 30, the structure and pose show Holbein's knowledge of current Venetian compositional formations (as exemplified in the work of Titian and Lotto).

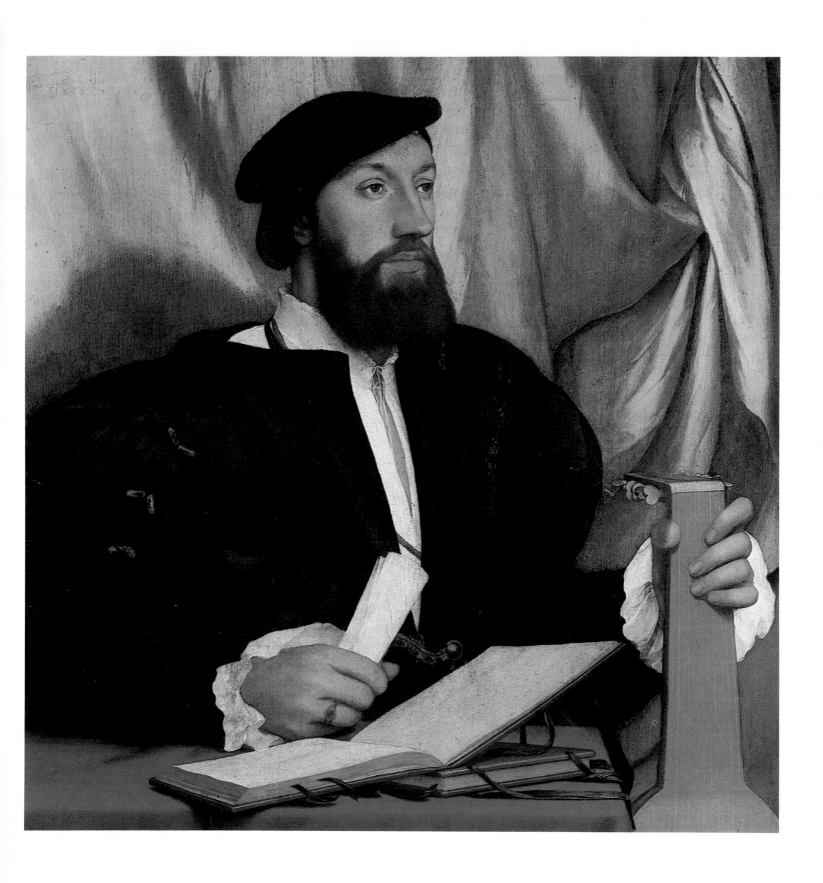

Sir Richard Southwell

1536. Chalk, pen and brush on paper, 37 x 28.1 cm. Windsor, Royal Collection

A comparison between the drawing and the finished portrait of Southwell (Plate 29) shows how complete Holbein's conceptions were before the painting was undertaken. Although corrections were sometimes made on the panel, the notation of light and shadow (down the back of Southwell's neck, for example) and such identifying features as the scar on his throat, were pinpointed from the start with such authority that the static massed volume of the sitter was fully in realized before paint was applied.

The range of chalks – predominantly black, with some red and yellow for definition – is usual for Holbein in this period, with some influence from Clouet's style (see Fig. 23).

The face is changed very little between the two works – it is the garment that is altered; and from its monochrome sobriety the painting gains a simplified power that is the hallmark of the mid-1530s work. The annotation running vertically up the right-hand side of the drawing reads 'the eyes a little yellowish', a rare instance of Holbein's departure from reliance on his extraordinary visual memory.

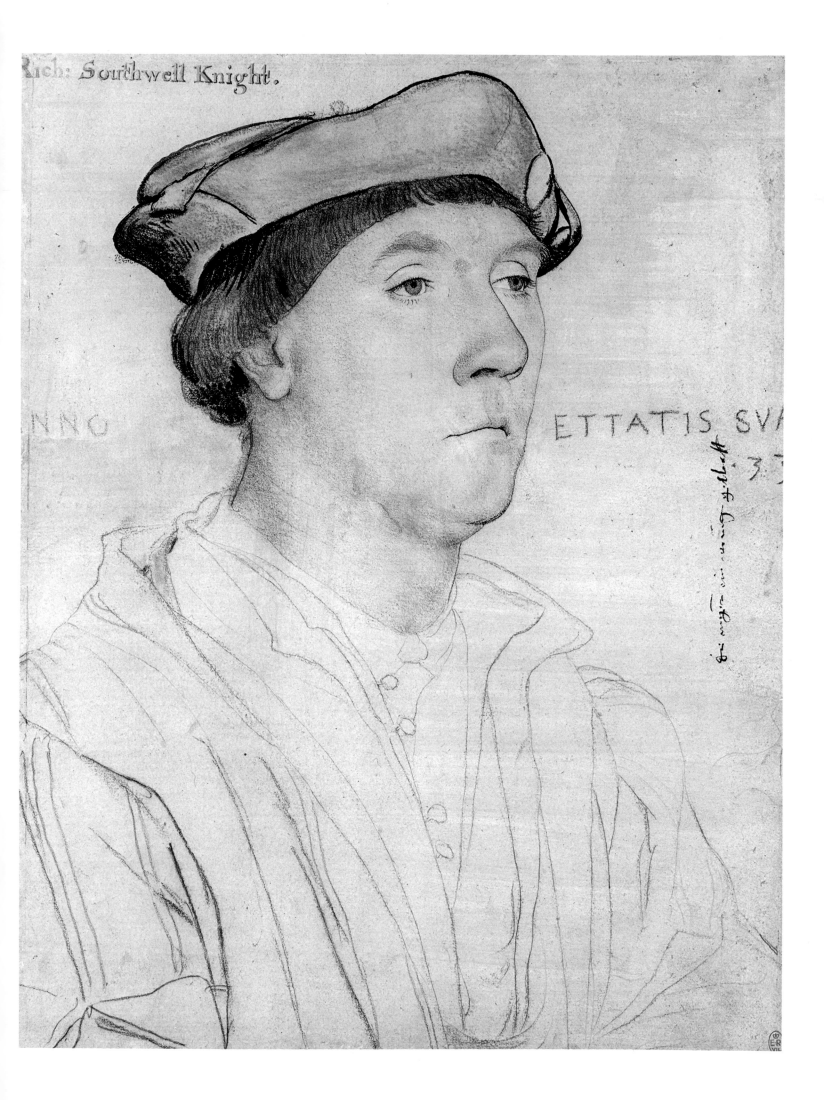

Rich: Southwell Knight.

ANNO ETTATIS SVA
 3

Sir Richard Southwell

1536. Oil on wood, 47.5 x 38 cm. Florence, Uffizi

As might be surmised from the somewhat cold and sinister expression on Southwell's face, he has come down to posterity as one of the most calculating and treacherous members of Henry VIII's court. He became a creature of Thomas Cromwell and was instrumental in aiding Richard Rich in his attempts to force the imprisoned Sir Thomas More to incriminate himself in 1532. Southwell also made accusations against a childhood friend, the Earl of Surrey, that led to the latter's execution. Cromwell employed him as a general factotum during the dissolution of the monasteries between 1536 and 1539. He was knighted (after Cromwell's downfall) in 1542. Southwell later abjured Protestantism, and thus found favour under Mary I (1553-8), but as a result he was shunned in Elizabeth's reign. He died c.1564.

The darkly penetrating survey of the cold gaze of the sitter certainly does not flatter, but dares not condemn. Did Holbein's detached professionalism as a painter came under strain when depicting the agent of destruction of More, his first major patron? The simplicity of the background and the emphatic linearity of the design accentuate the overall sense of calculation, as though the artist wanted to concentrate on abstract elements. In this the picture has an affinity with Bronzino's portraits of the contemporary Medici court at Florence (see Fig. 26). Appropriately, the work was later given by the great connoisseur and collector, the Earl of Arundel, to Cosimo II, Grand Duke of Tuscany, in the seventeenth century.

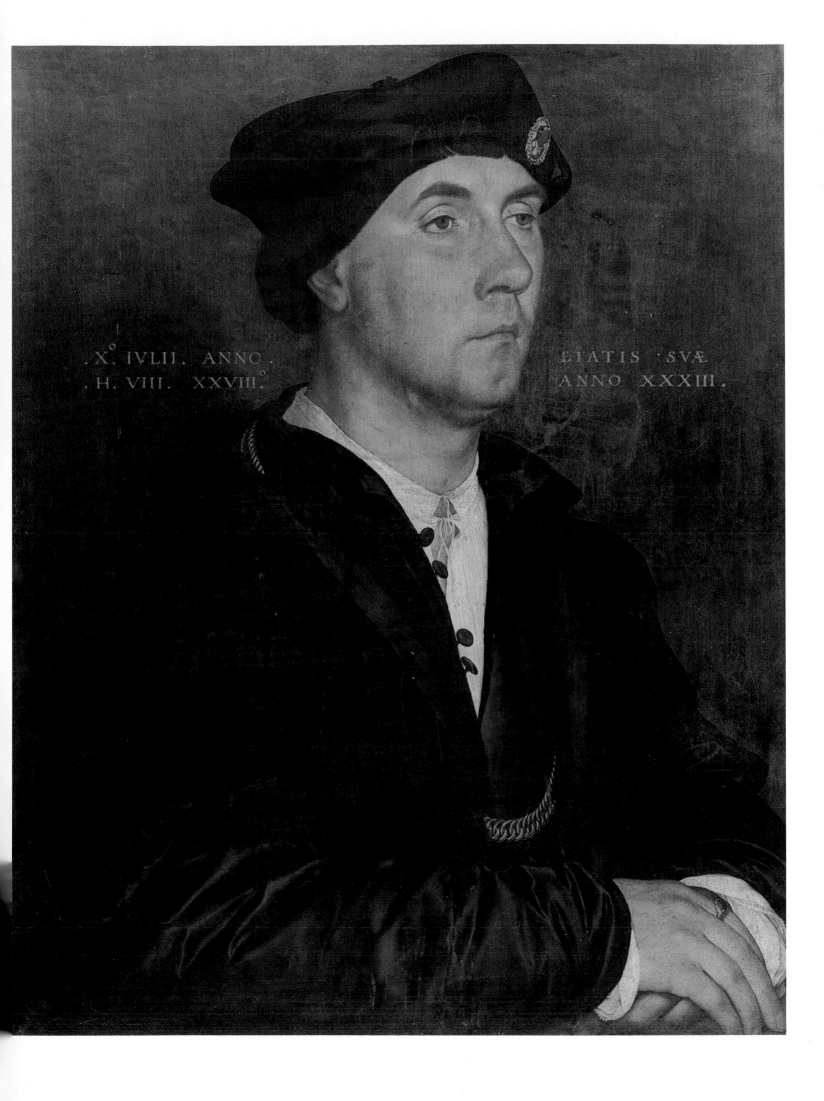

.X.̊ IVLII. ANNO. ETATIS . SVÆ
.H. VIII. XXVIII.̊ ANNO XXXIII.

Jane Seymour

1537. Oil on wood, 65 x 40.5 cm. Vienna, Kunsthistorisches Museum

The ill-fated third wife of Henry VIII died after giving birth to her husband's desperately hoped-for male heir, later Edward VI (1547–53). Jane Seymour was hurriedly married to the King following the disgrace and execution of Anne Boleyn in May 1536. Pious contemporary accounts stress her good nature (in contrast to the denigrated Anne), but not much of that is allowed to surface in Holbein's portrait, which depicts a figure frozen in an official sense of responsibility. The simplicity of the shadowed background accentuates the increasing richness and boldness of design and adornment in Henrician court fashion, and the artist's skill is pre-eminent in creating the sheen and lustre of the precious stones. Great attention has been paid to the realism of the silver thread in the queen's dress, and this new opulence was to be echoed in the portrait of Henry himself (Plate 36).

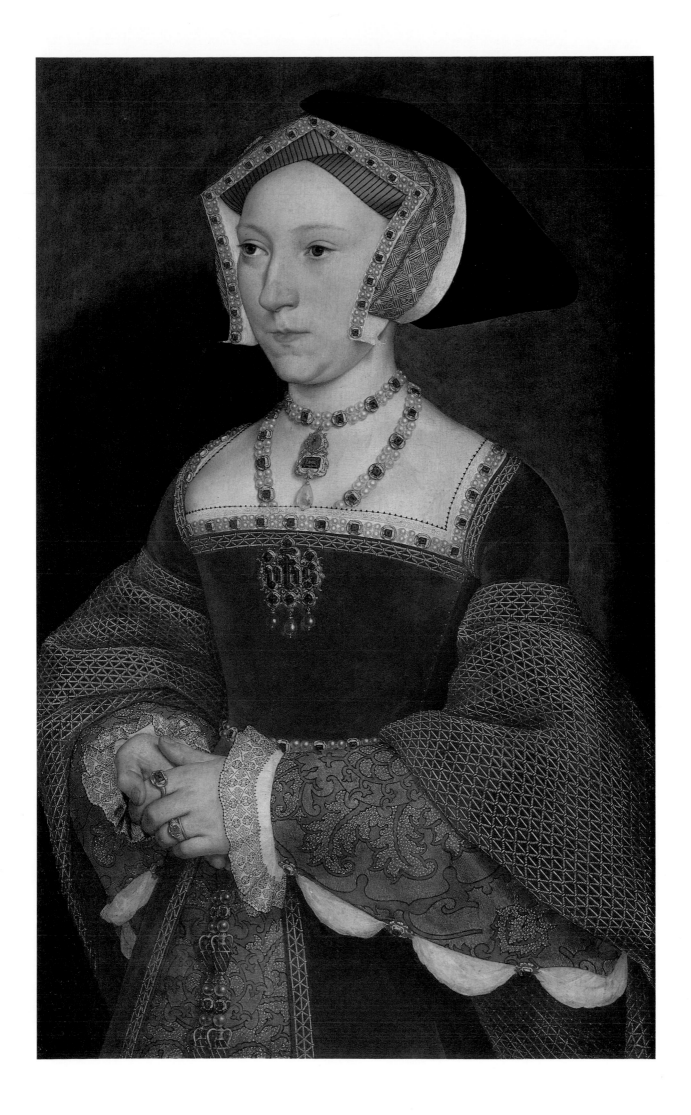

The Triumph of Riches (copy by Lucas Vorsterman the Elder after Holbein)

Pen and brown ink with brown, grey and green washes, black and red chalks and blue and white bodycolour, 44.4 x 119.3 cm. Oxford, Ashmolean Museum

This, and its pendant the *Triumph of Poverty*, originally hung in the Great Hall of the German Steelyard in Blackfriars, London, even after Elizabeth I rescinded the company's privileges during the post-Armada surge of nationalism in 1589. In about December 1609 the works were presented to Henry, Prince of Wales (who died in 1612) and thence entered the Earl of Arundel's collection in Holland via Charles I in 1641. They were destroyed by fire at Kremsier Castle in 1752. Two sets of copies now exist, of which the coloured version in Oxford is considered the most accurate.

With Plate 32, the *Triumphs* give evidence that Holbein's continental interest in allegorical presentation, which frequently overflowed into his portraiture, was maintained in England despite the paucity of native interest in the increasingly reformist climate. The works functioned as a moral admonition to the denizens of the Steelyard, much as the allegorical designs often displayed in law-courts defined the qualities required of legal administrators.

Ancient Plutus, god of riches, is drawn along by wealthy men before whom blindfolded Fortuna throws money. The horses, as vices (for example, Avarice) are controlled by the virtues needed when wealth comes one's way. The Latin inscription, at one time ascribed to More, translates as 'Gold is the father of deceit and the child of grief. He who lacks it is in sorrow; he who possesses it is fearful'. Mantegna can be cited as a visual source, primarily his *Triumph of Caesar* panels (now at Hampton Court), which Holbein probably knew through engravings.

Fig. 28
Preparatory drawing
for The Triumph
of Riches
Pen and brown ink
with brown and grey
washes, heightened with
white bodycolour,
25.3 x 57 cm.
Paris, Musée du Louvre

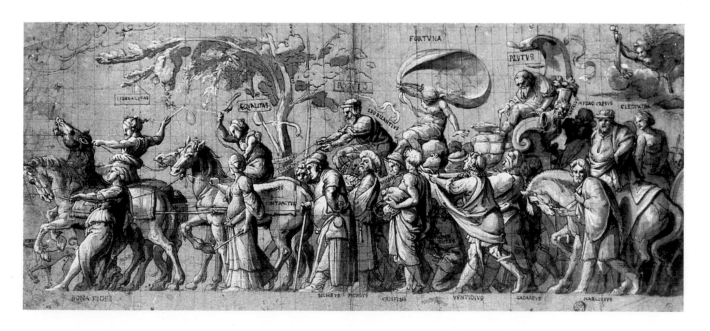

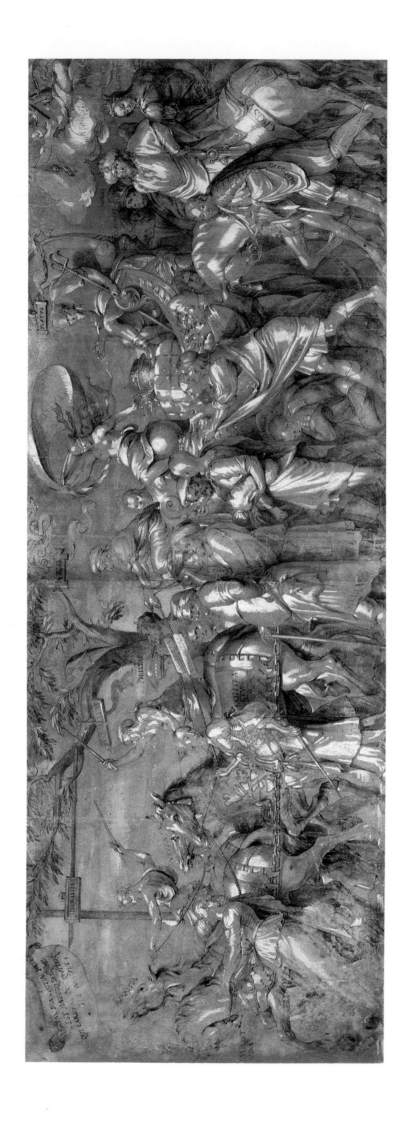

32 Solomon Receiving the Homage of the Queen of Sheba

c.1535. Silverpoint, pen and brush on vellum, 22.9 x 18.3 cm Windsor, Royal Collection

This delicate and elegantly constructed group of courtly figures clearly alludes to Henry VIII, in the swaggering pose of the seated, bearded king, while the architecture is reminiscent of that in the Whitehall painting (see Fig. 14). Henry VIII was known to consider himself a Solomonic figure, an identification which allowed him to take over the spiritual guidance of the state after 1536 with a modicum of conscience. The Queen of Sheba herself symbolizes the Church's new subservience to the Crown, made explicit by the altered quotation, from II Chronicles 10, v7–8, which adorns the scene.

It is difficult to date the work but it has been suggested that, like the Washington portrait of Edward, Prince of Wales (Plate 45), it was a presentation work for the court for New Year's Day, 1540. Its small size is also unusual in Holbein's *oeuvre*; the intricate working of pen and brush, watercolour, bodycolour and gold paint, particularly in the architectural detailing, belongs as much to old-fashioned Tudor gothic as to contemporary mannerism.

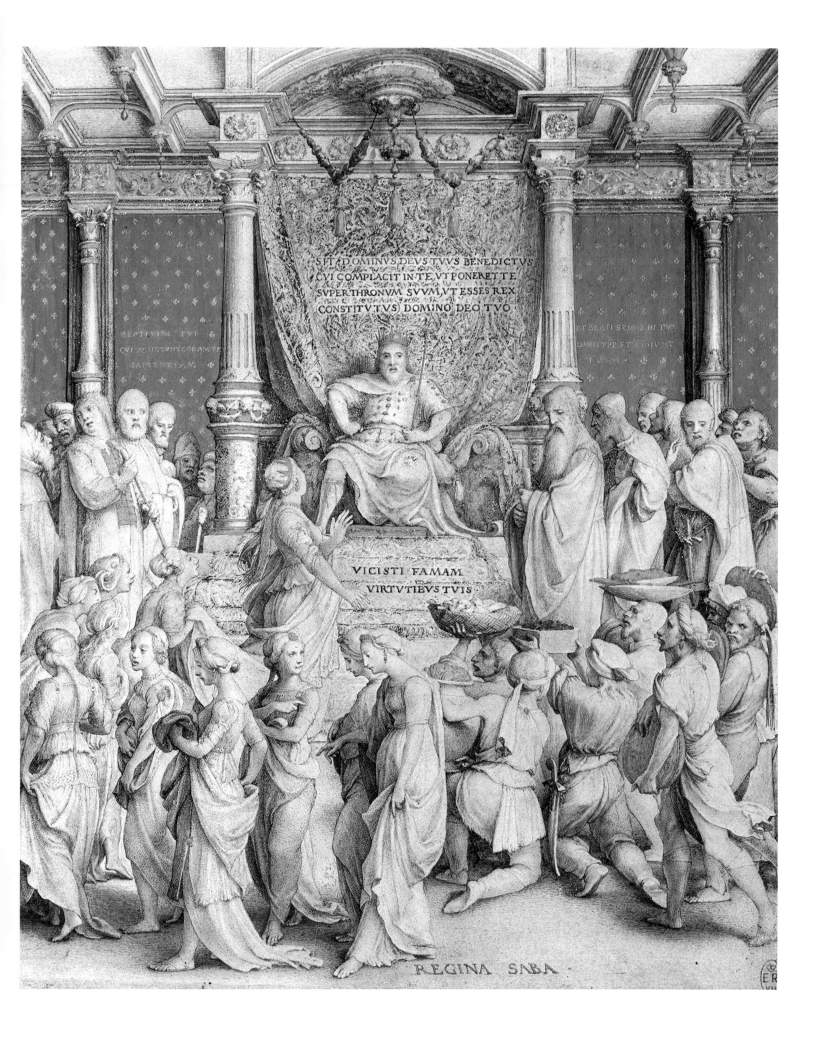

33 Jane Seymour's Cup

c.1536. Pen, indian ink and watercolour, 37.6 x 15.5 cm. Oxford, Ashmolean Museum

Since his youth Holbein had been involved in the design of artifacts and it is not surprising that the English court, following the King's lead, should have set him to further practice. Besides this cup, other articles included elaborate centre-piece designs (of fountains and basins) for court banquets, convoluted decorative 'parade daggers', and a case for a clock for Sir Anthony Denny not disimilar in design to the Queen's cup, of which the British Museum has another version.

Near the top the Queen's motto, 'Bound to Obey and Serve', can be seen, and 'H' and 'J' love-knots embellish the central panel.

The actual piece was sold in Holland in 1625 on Charles I's orders, and was described as 'a faire standing Cupp of Goulde, garnished about the cover with eleaven Dyamonds ... seaventeene Table Dyamonds and one Pearle Pendant upon the Cupp ... weighing Threescore and five ounces and a half'. Possession of such objects carried inordinate prestige in courtly circles.

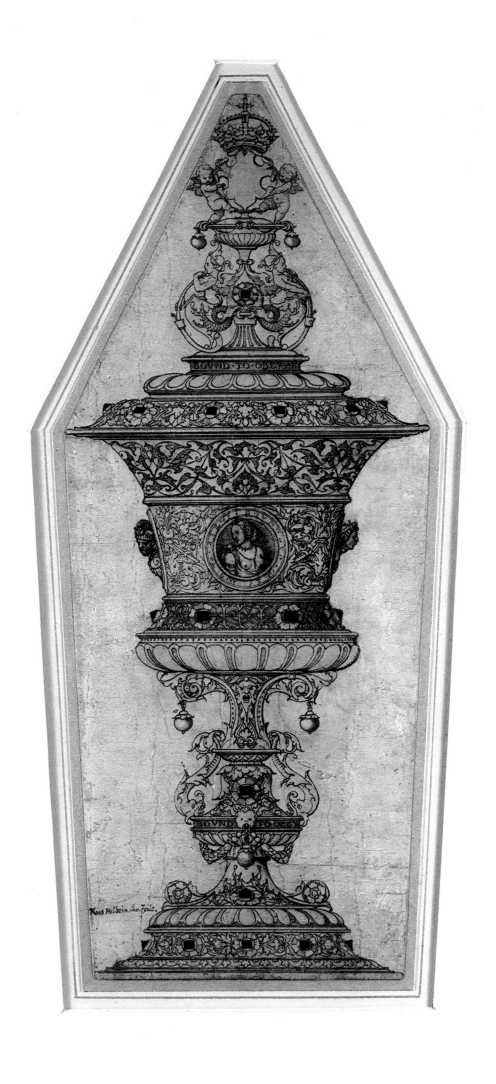

Lady Elyot

1532–3. Chalk, pen and brush on paper, 28 x 20.9 cm. Windsor, Royal Collection

Although contemporaneous with such portraits as that of Gisze (Plate 22), this pair of portrait drawings (see Plate 35) nevertheless had a different goal. The examination of intellectual or ideological stance or status was not much sought after by the subjects of most of the English court and society portrayals Holbein undertook. That was more the domain of his German merchants and scientists. The pragmatic accuracy of 'warts and all' delineation was what fascinated the English clients most, and such interest in detail can be traced back to the national traits in medieval manuscript illumination, where natural forms rather than abstract or geometrical patterns abound. Sometimes, the sitters were happy enough with Holbein's preparatory chalk drawing, and finished paintings did not ensue. There are no known paintings connected with either this drawing or Plate 35.) The native perplexity over perspective and foreshortening, which partly explains why the miniature became so favoured in later Tudor times (since it precludes much of either), must have made Holbein's mastery of both appear astounding.

The starchy headdress Lady Eliot wears seems to have been of a design baffling even to Holbein (he had had trouble depicting Lady Guildford's in 1527), probably because of the way in which it prevents that definition of the back of the head which allows the face to jut into the picture space convincingly.

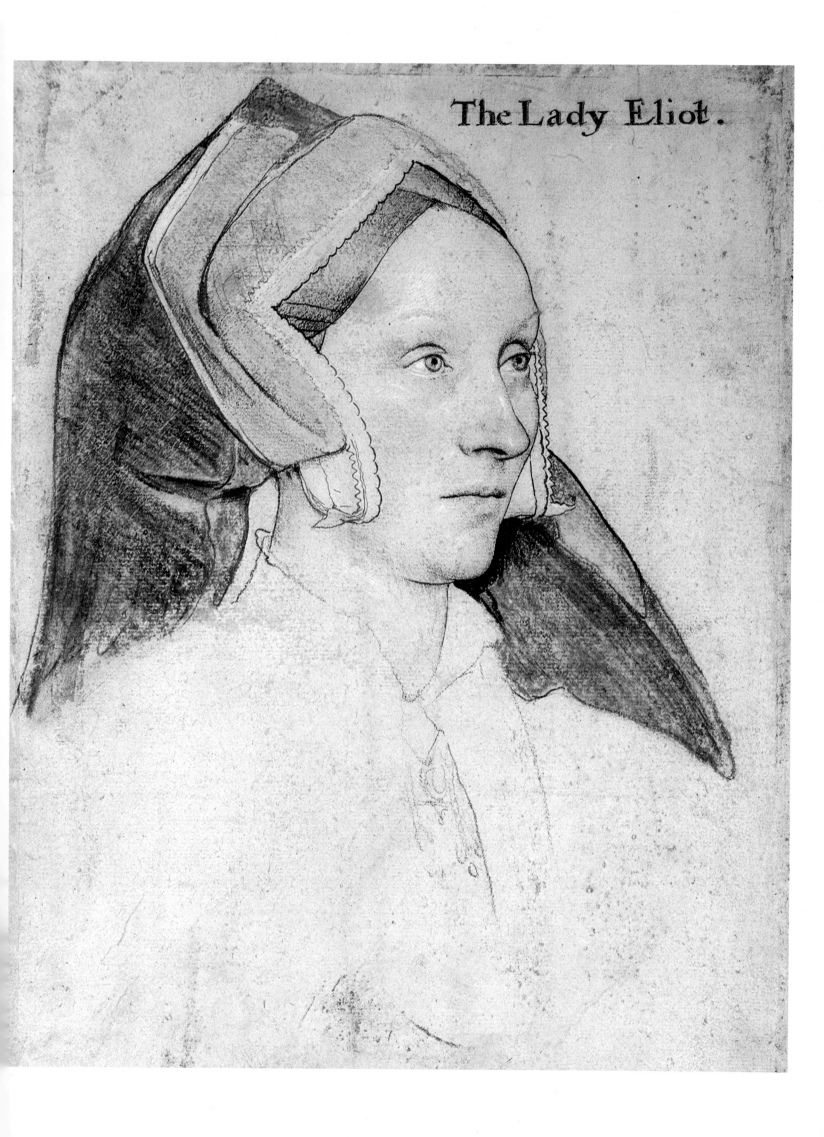

The Lady Eliot.

35 Sir Thomas Elyot

1532–3. Chalk, pen and brush on paper, 28.6 x 20.6 cm. Windsor, Royal Collection

Here, the flat hat and the falling hair give the head greater solidity, accentuated, as in the preceding plate, by the vaporous quality of the upper body. The striking use of black and yellow in each case sharpens the pink colouration of the prepared paper (useful for rendering flesh tones), and makes the drawing more forceful. As in earlier portrait drawings and the 1527 portrait of More, stubble on the man's chin accentuates sense of 'here-and-now', the living presence marvelled at in the inscription on Derich Born portrait's (see page 5).

Elyot was a member of Sir Thomas More's circle and praised him in 'the boke named the Governour', his great treatise on education (1531). After More's execution however, he reneged, asking Cromwell to forget this ertswhile friendship. The *Gouvernor* was to wield influence up to and throughout Elizabeth I's reign, with its advocacy of the complete training a Renaissance mind and body would need, not restricted to narrow, academic learning alone. The book is thought to have have been instrumental in determining the reformers to set up a tier of academies – the King Edward VI grammar schools – in the early 1550s.

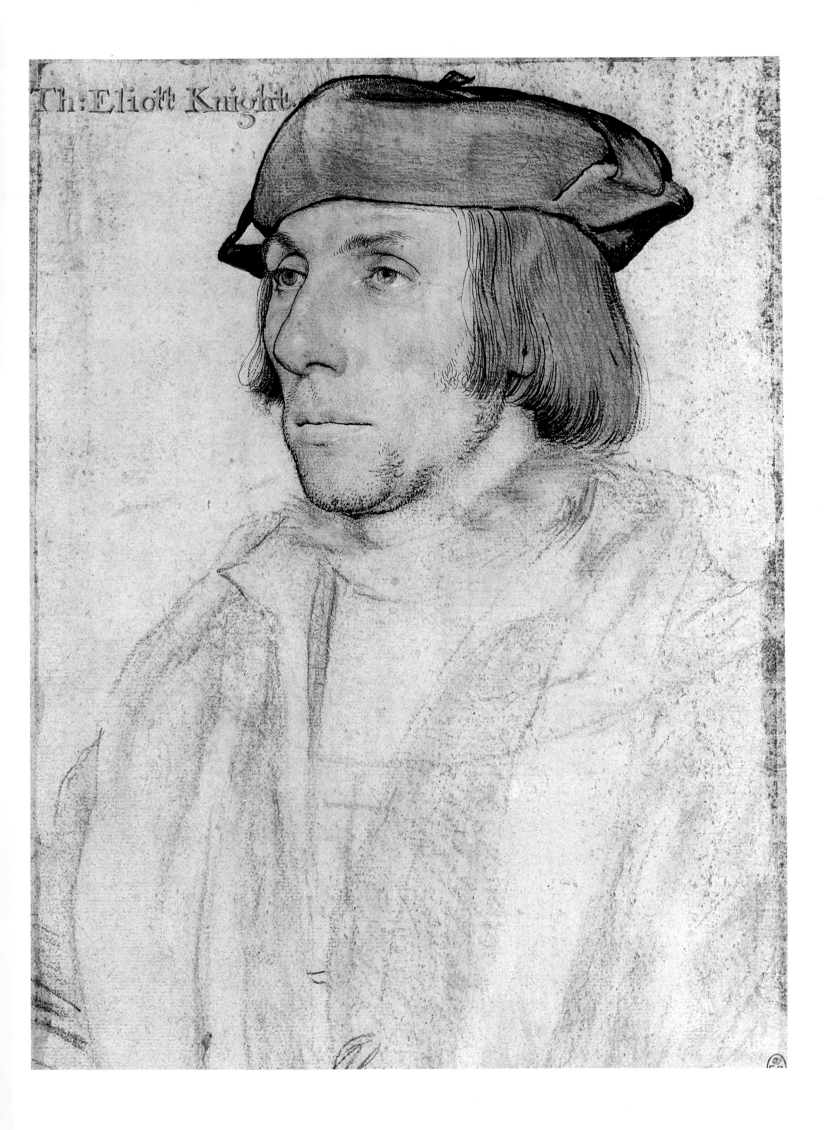
Th:Eliott Knight.

Th:Eliott Knight.

c.1536. Madrid, Thyssen Collection

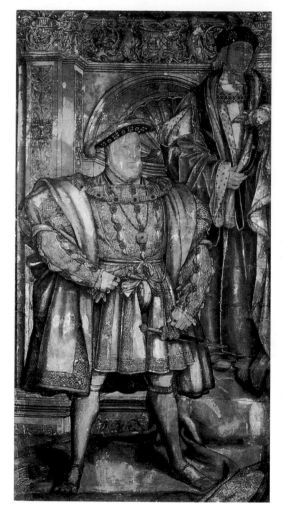

This is the quintessential image of the overbearing and tyrannous monarch, from the year the dissolution of the monasteries (and the consequent appropriation of their wealth for the Crown and its servants) was instigated. Holbein depicts the King at 'face value', without flattery, emphasizing the small, humourless eyes and mouth, the curiously flat cheeks and chin. Henr's bulky and capricious authority haunts the work despite its small size. Its condensation of magnificence run riot here takes the form of real gold used in the chain, jewellery and collar.

The portrait is undoubtedly a tour de force; after its execution, Holbein's position at the court seems to have been secure, and he was used as a painter-ambassador when the King's marital plans unravelled in the late 1530s. Only his misleading portrayal of Anne of Cleves (Plate 40) would check his popularity.

The subsequent spawning of similar but less effective portraits of the king by Holbein's followers has tended to obscure the compelling mixture of simplicity and realism displayed in this design – the tilt and curve of the black and white hat, the fearful symmetry of the jewelled jacket and the modelling of the hands: imitators often managed either simplicity or realism but never both.

Fig. 29
Henry VIII (detail
from the cartoon for
The Tudor Dynasty
mural)
c.1537. Brush
drawing with black
ink, and purple, brown,
grey and black washes,
on backed paper
 mounted on canvas,
257.8 x 137.1 cm.
London, National Gallery

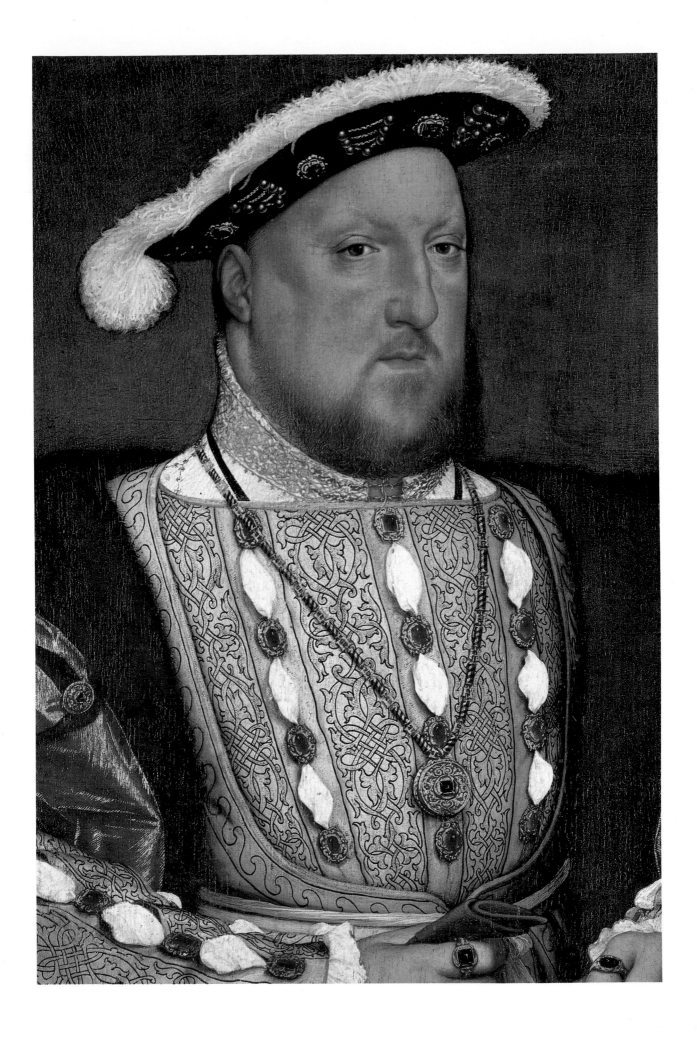

De Vos van Steenwijk

1541. Oil on wood, 47 x 36.2 cm. Berlin, Staatliche Museum, Gemäldegalerie

The sitter, a member of a Dutch family, has been identified through the coat of arms inscribed on his index-finger ring. The portrait shows a considerable tightening and simplifying of the composition that would pervade Holbein's *oeuvre* in the last few years of his life. Rich, shiny blacks come into favour, handsomely set against the passive blue background with its gilt inscription. The articulation of light against dark grows bolder too; the faces and hands gain in emphasis and a monumental linearity emerges in the treatment of the clothing against the background.

This stylistic development was perhaps a reaction against the small-scale filligree required for the portrait miniatures which were being produced in increasing numbers during this period, although both formats share the use of flat blue backgrounds.

ANNO 1541

ÆTATIS SVÆ 37

Design for a Pendant

c.1533–36. Pen and ink with watercolour, 37.3 x 14.3 cm. London, British Museum

The mixture of abstract and natural design here (in the diagonal sprigs of leaves and uncurling fern-like stems) is an effective compromise between native English taste and that of imported mannerism, with its liking for grotesquerie and distortion. The harmonic regularity of the design is far less flamboyant than its contemporary Italian or French equivalents and symmetry was to maintain its sway over English design throughout the century.

Such pendants dangled from necklaces, over the upper chest (see Plate 42) and did not differ greatly in design from such features as the Garter and other badges of office (see Plate 36).

Here, Holbein has completed the notation of the jewels; in other designs, such as the 'parade dagger', he was content to leave areas blank for professional colourists to fill in.

It is thought the design may have been commissioned as one of many pieces Holbein provided for Anne Boleyn in her hey-day from 1533 to 1536.

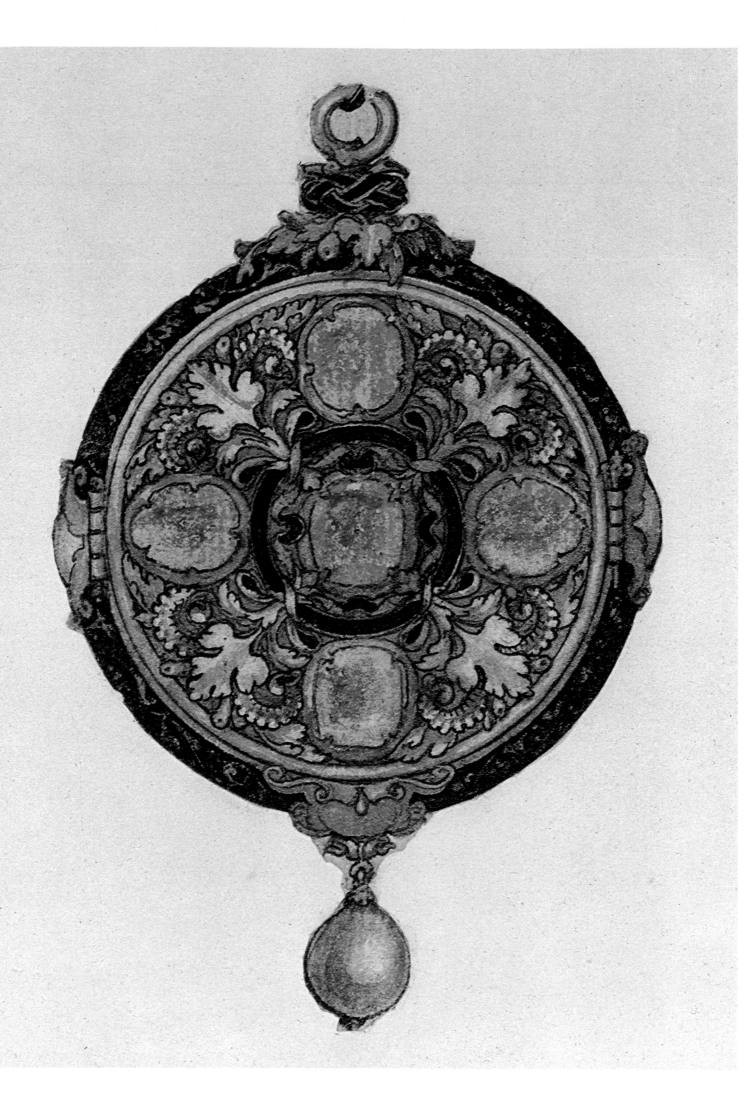

Simon George of Quocote

c.1535. Oil on wood, 31 cm diameter. Frankfurt, Staedelsches Kunstinstitut

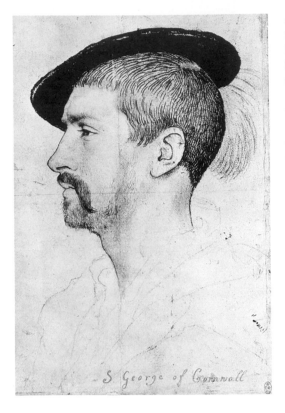

Fig. 30
Simon George
of Quocote
1536. Pale pink priming,
black, red and yellow
chalk with Indian ink,
28.1.5 x 19.3 cm. Windsor,
Royal Collection

At the other end of the spectrum of portraiture from the blatant display of regal power in Plate 36, is the aesthetic delicacy and reverie of this circular portrait. It is also Holbein's only profile portrait. A minor court figure, Simon George sports a fashionable hat similar to the King's, a hat whose circularity echoes that of the work itself.

Holbein had avoided the profile hitherto in England since it reduced the scope for his sharp yet reticent portrayal of personality. After Holbein's death, this format became popular for a while among his followers, perhaps for the very reason that it made a less searching examination of their ability to express psychological nuance.

The humour in the eyes and some inscrutable edge of a smile about the mouth is remarkably conveyed here, although these qualities had been lacking in the blunt preliminary drawing.

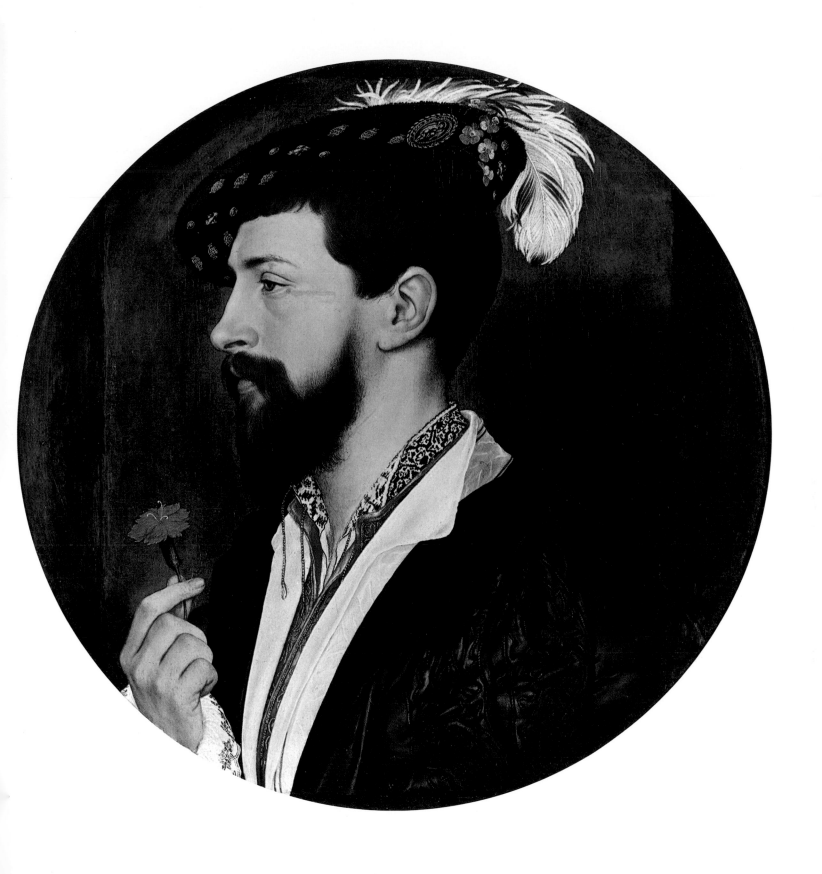

Anne of Cleves

c.1539. Watercolour on parchment mounted on canvas, 65 x 48 cm.
Paris, Musée du Louvre

Despite its bland, unprepossessing appearance, this royal commission is coloured by a controversial history. Holbein was placed in an impossible position: despatched to Düren with orders to produce an instant likeness of Henry VIII's next intended bride, he needed to exercise diplomacy and tact – he would have had to show the results of his rapid sittings to the foreign officials. As it is, Anne's dress seems to have fascinated him more than the strangely lifeless symmetry of her features. Henry's displeasure at finding Anne of Cleves more like a 'fat flanders mare' when she arrived for the marriage ceremony in January 1540 cost Holbein dear in prestige, and he received no further important work from this quarter.

Belying her appearance, Anne of Cleves, like Christina of Denmark (Plate 41), was no fool. Despite – or because of – the evident humiliation of the failed marriage she obtained a handsome settlement from Henry and lived in quiet comfort in England until 1555. Henry's two subsequent wives were English.

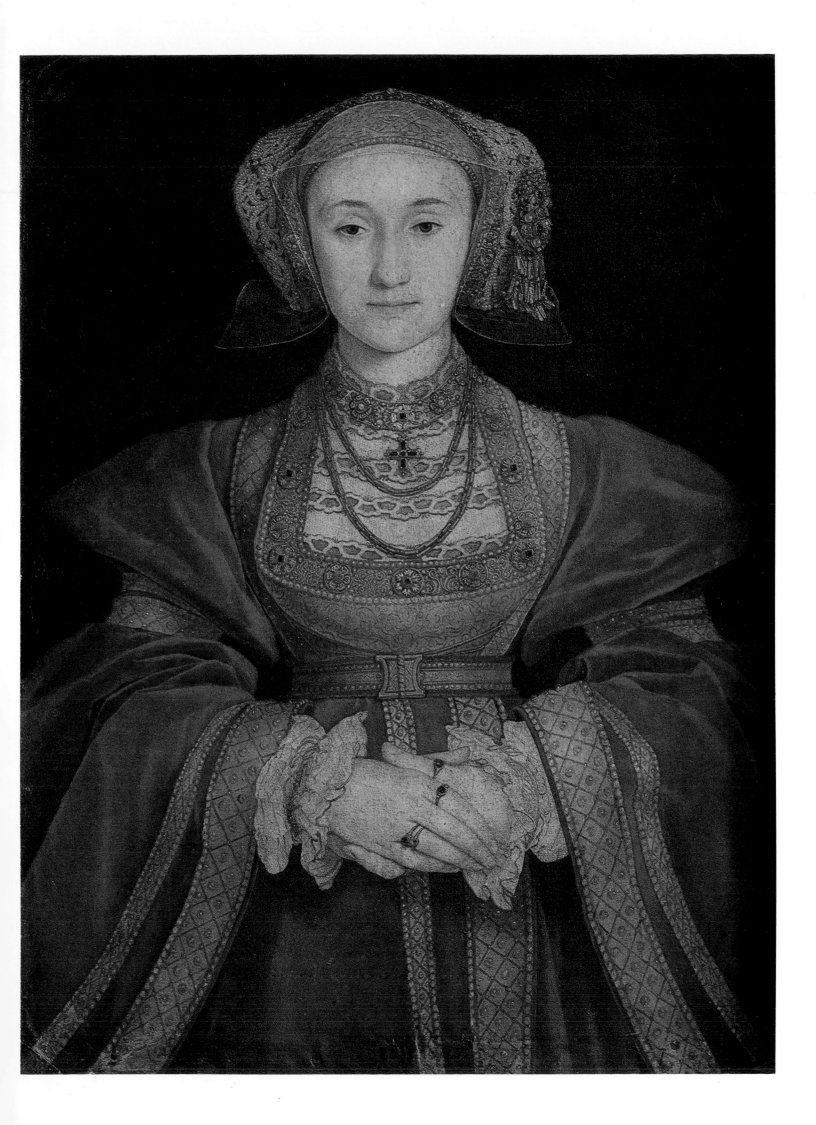

1538. Oil on wood, 179.1 x 82.6 cm. London, National Gallery

After Jane Seymour's untimely death – and even before her burial – Henry began searchng desperately for a fourth spouse. Negotiations with the French fell through, but those in Brussels concerning Christina led to Holbein's being sent there; this work is the result.

Holbein's drawing, finished after only three hours, impressed officials – 'Mr Haunce ... hath shoid hym self to be the master of that siens (science) for it is very perffight' – and more importantly, Henry himself, who immediately ordered the full-length portrait. A rival version from the Brussels court was derided by the same official as 'but sloberid (slobbered)'. It would be difficult to match the poise and calm grandeur of Holbein's conception, with the elegant simplicity and smooth texture of the Duchess' face and the material of her mourning dress – and the trace of mystery in the cast shadow to the left.

The engaging expression on her face suggests the common sense that sabotaged Henry's hopes for marriage; 'if I had two heads, one would be at the service of the King of England'. After such a work, the pedestrian portrait of Anne of Cleves must have seemed inexplicable to court and King alike.

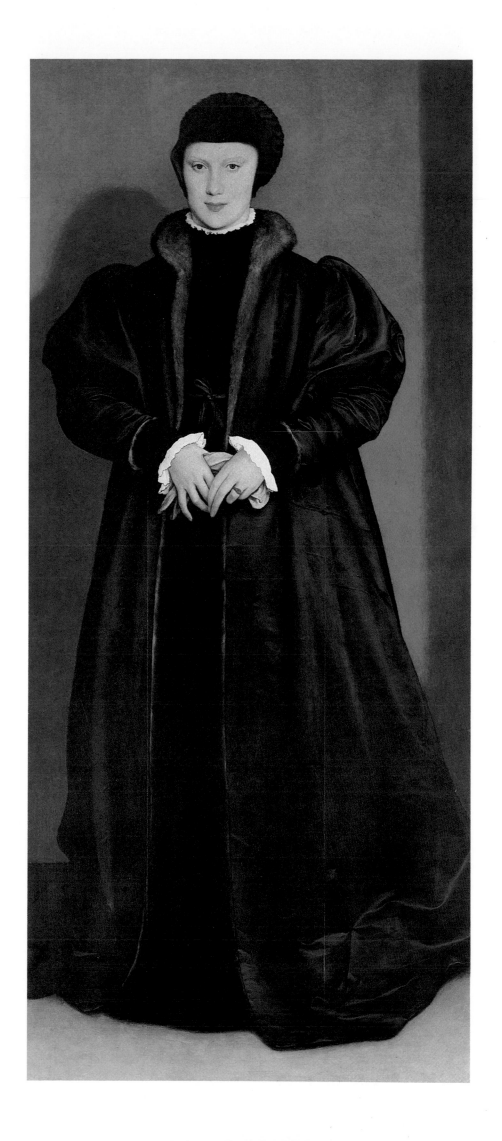

Portrait of an Unknown Lady (Catherine Howard?)

c.1541 Vellum mounted on playing card, 5.1 cm diameter. Windsor, Royal Collection

Fig. 31
Isaac Oliver
Unfinished miniature
portrait of Elizabeth I
London, Victoria and
Albert Museum

The first portrait miniatures were produced in France, their precursors being the small circular works commissioned by Francis I to celebrate the victory of Marignano in 1515. Jean Clouet (see Fig. 23) was among the early practitioners of this format, which seems to have arrived in England by 1526 in the form of French royal portraits. Ten years elapsed before Holbein's contribution, but his work marks an immediate advance over the productions of earlier native practitioners like Lucas Hornebout. The small scale and different medium – vellum mounted on playing card (and termed 'miniature' because of the lead (Latin *minium*) used in the paint did nothing to hamper Holbein's sturdy realism.

The identity of the lady is uncertain – the Romantic view of the 1840s judged it to be a portrait of Henry VIII's tragic fifth wife, Catherine Howard, executed for alleged adultery, although no ascertainable portrait of her exists elsewhere. What is certain is that, as in the examples of Plate 45 or the duo in Plate 46, Holbein's powers of characterization lost nothing in the confined space. Features of his late style include the clarity and simplicity of the background, often eschewing even the standard biographical information so as to maintain as direct a perception of the sitter as possible.

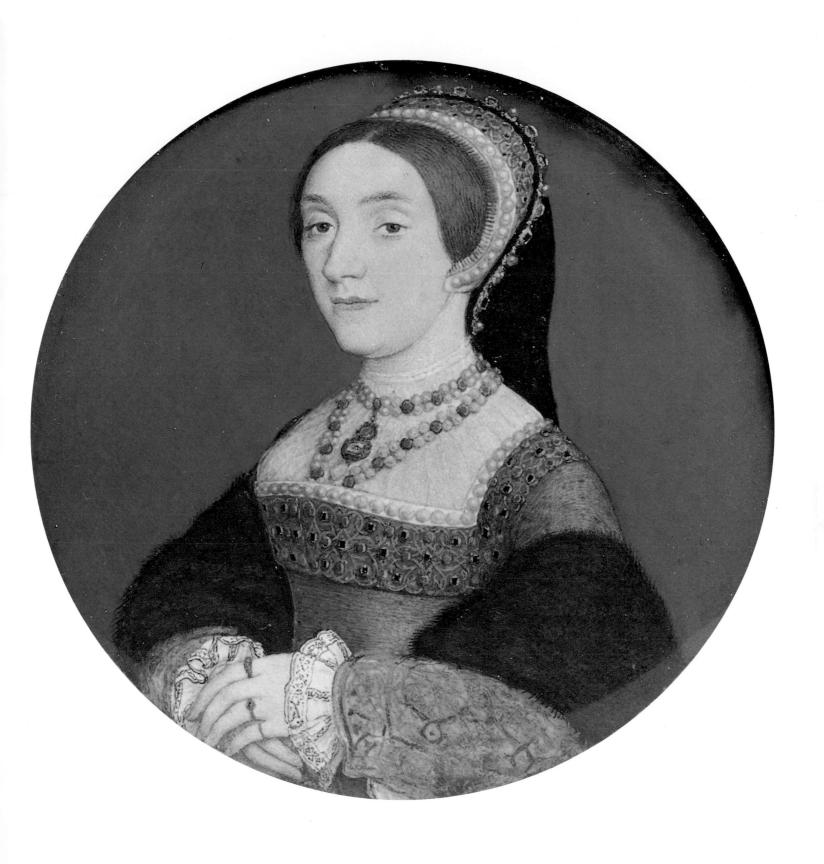

Henry Brandon and Charles Brandon

1541. Vellum mounted on playing card, both 5.7 cm diameter.
Windsor, Royal Collection

The equal of the miniature of 'Mrs Pemberton' in skill (Plate 46), this pair of pendant portraits of the near-royal relatives and schoolfellows of Prince Edward shows that the distilled power of quiet observation that is Holbein's main achievement in miniature 'limning' could draw personality and character even out of the very young. Both boys appear as differentiated individuals; Henry impatient with the sitting, on the verge of becoming fractious, the more stolid Charles transfixed by his role as sitter.

The refinement Holbein displays here was rarely bettered. The sad fate of the children casts a poignant aura across their portraits; the brothers died of the notorious 'sweating sickness' within an hour of each other in 1551. Because the elder died first, Charles was deemed to have been (very briefly) the third Duke of Suffolk, heir to the bosom-friend of Henry VIII's youth, whose third wife had been Henry's sister, Mary, the dowager Queen of France.

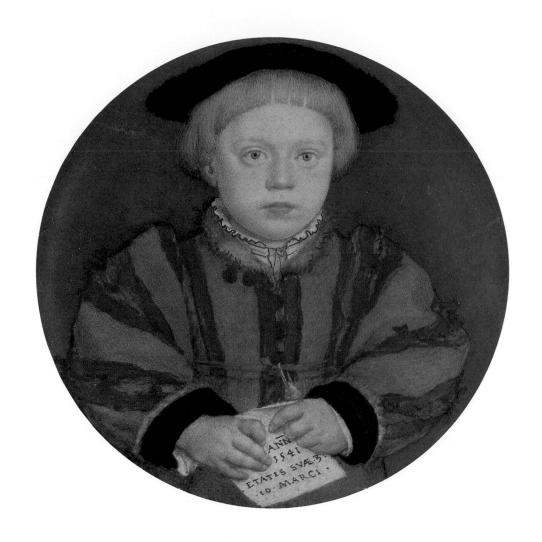

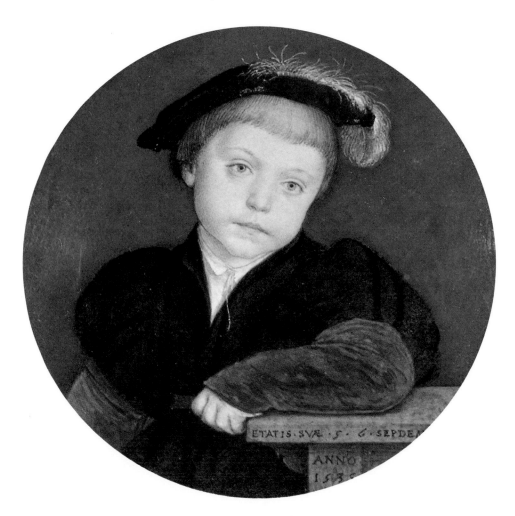

Edward, Prince of Wales, with Monkey

c.1541–2. Pen, ink and watercolour, 40.1 x 30.9 cm. Basle, Öffentliche Kunstsammlung

Holbein died when Edward was in his sixth year; portraits of the prince as an older boy were ascribed to Holbein until the nineteenth century, due to a mistaken reading of the date of the artist's death. This work is evidently from late in his life, when he seems to have been under great pressure to produce court portraits of a smaller dimension, in such time as could be wrested from diplomatic journeyings. Also, perhaps because few regal commissions came his way after the debacle around Anne of Cleves' portrait, he lowered his sights and produced drawings more highly coloured than those of the early 1530s as substitutes for paintings. Many of these have suffered from being hung as paintings as a result, some fading in sunlight as is the case here. Nevertheless, beneath the ghostlike outlines of the boy's face can be seen the attempt by Holbein to parallel aspects of the father's portrait in Plate 36; which goes beyond sartorial similarities to the bulky, frontal pose and the flat background, while the sketchy, spontaneous handling of the brushed-on colour gives a poignancy to the work more measured treatments cannot approach.

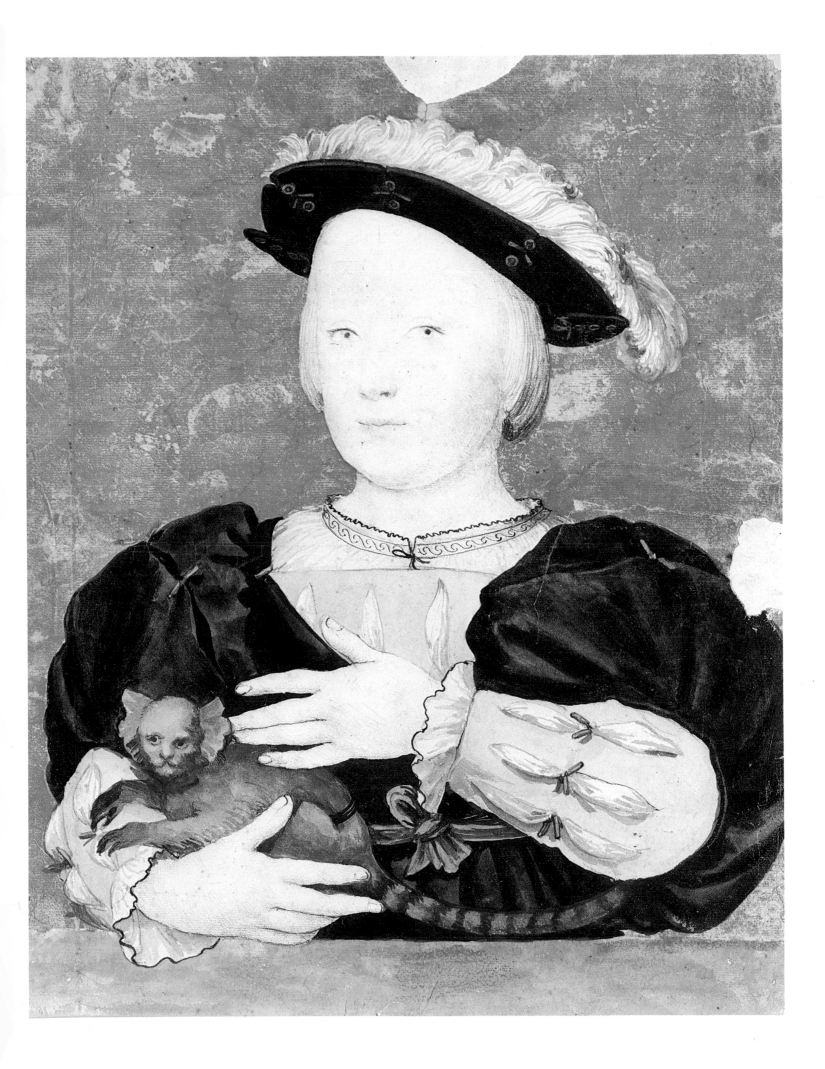

Edward, Prince of Wales

1539. Oil on wood, 57 x 44 cm. Washington, National Gallery of Art, Andrew W. Mellon Collection

Embellished with verses by court poet Richard Morysin, exhorting the prince to surpass his father's achievements, this portrait is imbued with sad irony; this apparently healthy-looking child would die of tuberculosis at sixteen.

The baby prince looks considerably more mature than his two years would warrant and, as in the previous portrait, his pose echoes the regal authority of his father (Plate 36). The gesture of the hands, found in Renaissance depictions of the infant Christ blessing onlookers, has another resonance. Holbein may have intended to legitimize the English Crown's new religious role by endowing it with the forms religious art could no longer pursue in Protestant England.

Painted on oak panel, the apparently conventional design is enlivened by the shadow behind and to the left, recalling the more powerful spatial definition of Plate 40, and the rich red, brown and gold colour combination gives a mellow impression of prescient childhood. The skill in the foreshortening of the right hand's extended fingers distracts somewhat from the flat facial features - a characteristic of Holbein's royal portraiture.

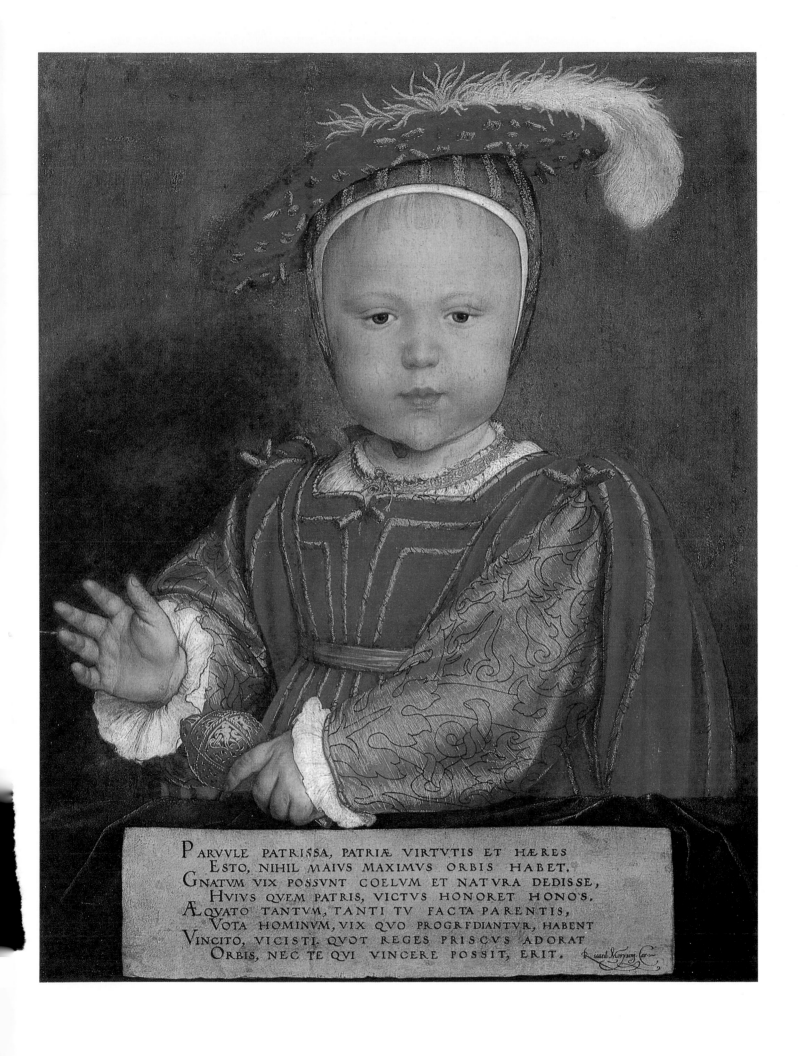

PARVVLE PATRISSA, PATRIÆ VIRTVTIS ET HÆRES
 ESTO, NIHIL MAIVS MAXIMVS ORBIS HABET.
GNATVM VIX POSSVNT COELVM ET NATVRA DEDISSE,
 HVIVS QVEM PATRIS, VICTVS HONORET HONOS.
ÆQVATO TANTVM, TANTI TV FACTA PARENTIS,
 VOTA HOMINVM, VIX QVO PROGREDIANTVR, HABENT
VINCITO, VICISTI, QVOT REGES PRISCVS ADORAT
 ORBIS, NEC TE QVI VINCERE POSSIT, ERIT. Ricard Morysyn Car

Mrs Pemberton

c.1535. Vellum mounted on playing card, 5.3 cm diameter.
London, Victoria and Albert Museum

This image of the twenty-three-year-old Mrs Robert Pemberton is acknowledged to be one of Holbein's masterpieces in this genre, transcending the wooden-looking figures that Hornebout had been producing for about a decade before. Holbein's working methods, using preliminary drawings as for full-scale portraiture, enabled him to capture mood and character memorably. The sitter's intent but gentle gaze out of the picture space and the subtlety of the colouring, which prefigures the austerity of his non-royal subjects from the later 1530s, condense the full presence of a life and personality onto a tiny surface area. The static, calm pose insists on the sitter's dignity - only the artist's assurance equals hers.

As with many privately commissioned miniatures, devised as keepsakes, it is set in a locket. This tradition, originating in the exchange of images between European monarchs and nobility as tokens of diplomatic goodwill, may be contrasted with the sharing of adulatory portraits of intellectual heroes around the circle of Erasmus and More (Plate 11). The miniature represented this form of admiration at its most intimate.

Much as they admired his work, neither Nicholas Hilliard (c.1547–1617) nor Isaac Oliver (1563–1619) employed Holbein's acute psychological realism in their own miniatures, developing instead a more emblematic presentation (Fig. 30).

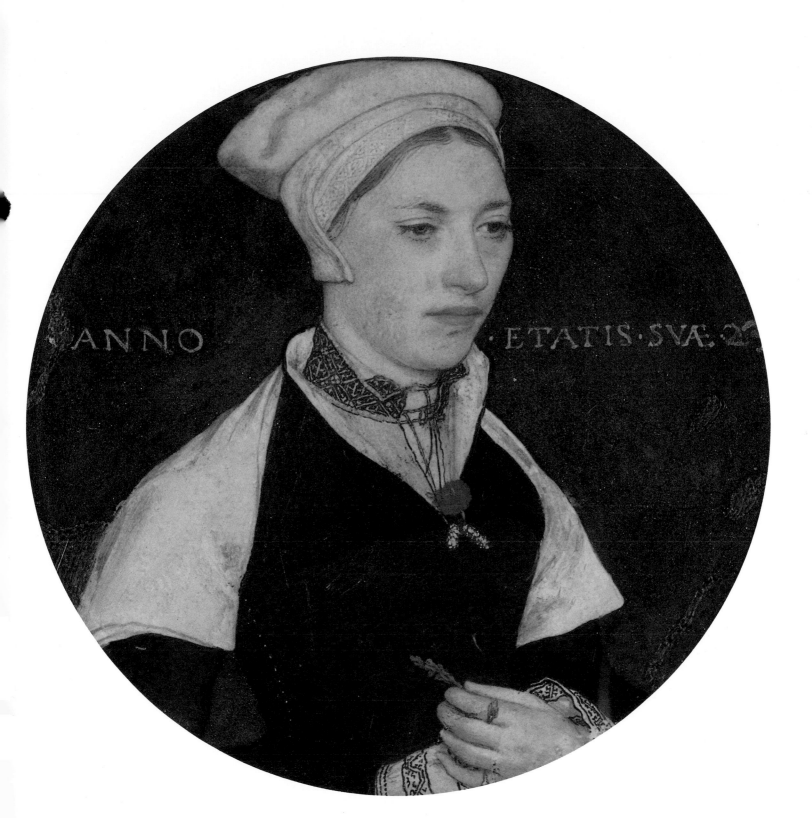

ANNO · ETATIS · SVÆ · 27

Portrait of a Man, supposedly Anton the Good, Duke of Lorraine

1543. Oil on wood, 51 x 37 cm. Berlin, Staatliche Museum, Gemäldegalerie

Although Holbein was still alive when the Duke was fifty-four (the age given in the gold inscription), there is no record of the sitter's presence in England at this time, nor of Holbein's visiting Lorraine. Nor do other likenesses of the Duke resemble this personage.

Whoever the subject may have been, Holbein's extraordinary control over the execution and painting invests the work with an authority that not even Jean Clouet at the French court could match. The linearity of the black cape is prefigured in a number of works from the 1530s (Plate 31), but without the soft richness shown here. The texture of the sleeve rivals Titian's achievements (Fig 26). There is an absence of the sheen Holbein prefers elsewhere, as on velvet (Plate 20) or satin (Plate 48). Surrounding imagery is kept to a minimum and nothing detracts from the bold monumentality of the figures. The thin gold of the inscription echoes the sprigs of gold in the cap. This refinement vanished from English painting after Holbein's death and the vigour and often splendid coloration that marks native production for the rest of the century could not encompass the truth to appearances which Holbein had made his goal.

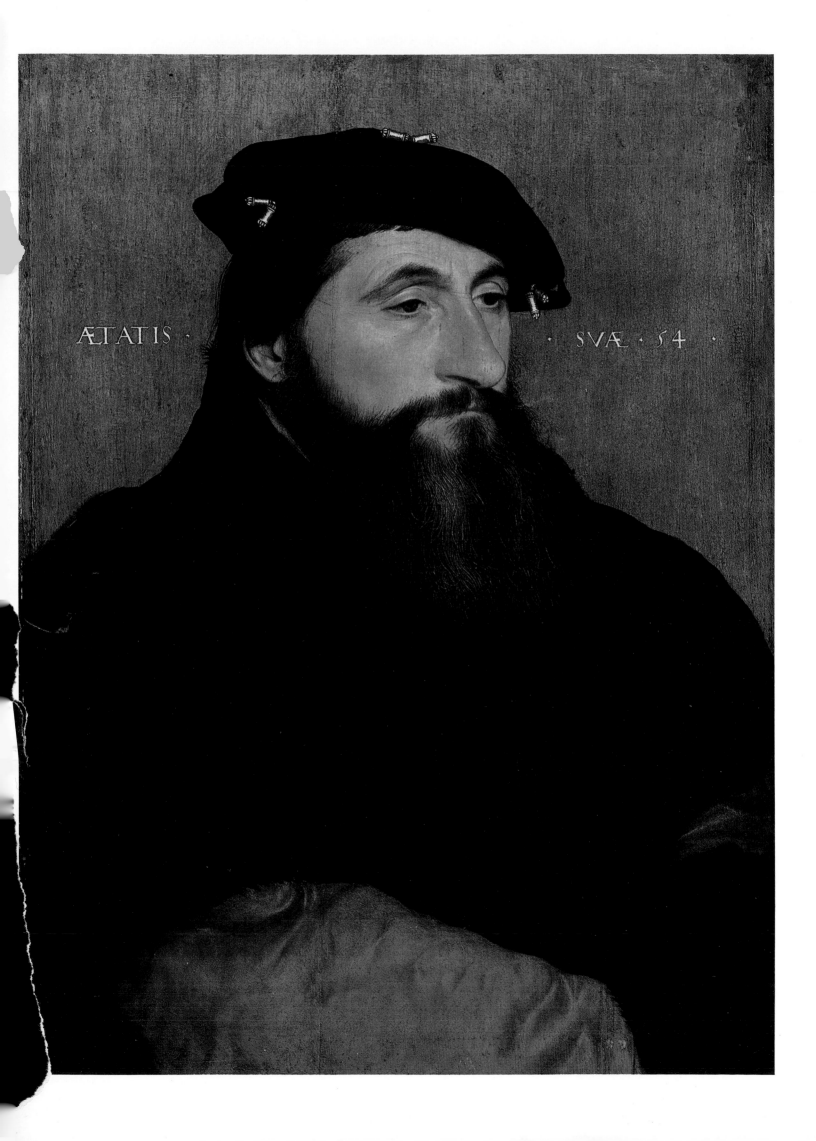

AETATIS · · SVÆ · 54 ·

Unknown Young Man At His Office Desk.

1541. Oil on wood, 47 x 34.9 cm. Vienna, Kunsthistorisches Museum

The awkwardness of the sitter's pose may result from its being an amalgam of two portraits of other people from about a decade earlier. This may explain the harder, more emphatically linear treatment of clothing and facial modelling, reminiscent of Holbein's style of the early 1530s.

The portrait has the static poise and fixity of the miniatures but on a larger scale, which allows scope for the addition of accoutrements. As in the picture of Derich Born (Plate 26), whose frontal gaze is so similar, the questioning directness pierces the viewer's conviction that it is merely a painted image. Although Hilliard's art would have different technical procedures, he wrote in *The Arte of Limning* (c.1600) of the reputation Holbein gained for the veracity of his work: '(there) came the most excelent Painter and limner Master Haunce Holbean the greatest Master Truly in both thosse arts after the liffe that ever was, so Cunning in both together and the neatest; and therewithall a good inventor, soe compleat for all three, as I never heard of any better than hee. Yet had the King in wages for limning Divers others, but Holbean's maner of limning I have ever imitated and howld it for the best...'

ANNO · DÑI · 1541 · ETATIS · SVÆ · 2 8 ·

CONSTABLE
John Sunderland

DEGAS
Keith Roberts

DUTCH
PAINTING
Christopher Brown

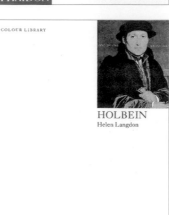

MAX ERNST
Ian Turpin

FRA ANGELICO
Christopher Lloyd

HOLBEIN
Helen Langdon

ITALIAN
RENAISSANCE
PAINTING
Keith Roberts

MAGRITTE
Richard Calvocoressi

MODIGLIANI
Douglas Hall

MUNCH
John Boulton Smith

PISSARRO
Christopher Lloyd

TOULOUSE-
LAUTREC
Edward Lucie-Smith